Lithographic Pressman's Handbook

by

George W. Jorgensen
Supervisor — Physics Division
Graphic Arts Technical Foundation, Inc.

and

Dr. Abrahim Lavi
Chairman — Systems Sciences
Professor of Electrical Engineering
Carnegie-Mellon University

Graphic Arts Technical Foundation, Inc.
4615 Forbes Avenue; Pittsburgh, Pennsylvania 15213

ISBN 0-88362-016-2
Library of Congress Catalog Card Number: 77-4641

Graphic Arts Technical Foundation, Inc.
4615 Forbes Avenue, Pittsburgh, Pennsylvania 15213

Preface

The principal purpose of this handbook is to aid the pressman in attaining control of print quality on the printed sheets running through a single-color sheet-fed lithographic press. If one thinks of each unit in a multicolor press as being a single-color press, then much of the data in the *Handbook* is also applicable to multicolor presswork.

A second purpose of the *Handbook* is to put in the hands of the lithographic pressman a catalog of explicitly defined and illustrated lithographic press printing problems coupled to all the known causes and possible remedies. As everyone recognizes, any remedial steps that might be taken to alleviate a specific problem may result in other print quality changes. Therefore, all the remedies listed are cross-referenced, in a very convenient way, to all the known consequences of each suggested remedial action.

The information is presented in both a straightforward reading form and a tabular form. The table for each problem simply suggests the *direction* in which to make adjustments. The *degree* of adjustment is left to the pressman's experience, and is usually best determined by making small progressive changes. The adjustments suggested are based on the assumption that the press is not damaged or grossly out of adjustment; that ink and dampening systems are in good condition and set properly. The feeder and delivery mechanisms are not covered; nor are sheet-insertion devices. The press manufacturers' instructions should be followed when such adjustments are needed.

The information in the *Handbook* is based on the presently available knowledge of the lithographic press process. It is GATF's intention to periodically revise and update the charts as new knowledge is acquired. To this end, the authors welcome comments and suggestions from anyone who uses the Handbook.

The authors wish to acknowledge the help and cooperation of Lisle Caldwell, Frank Cox, David Crouse, Alan DePaoli, Harry Hull, Dr. William Schaeffer, and Charles Shapiro of the Foundation staff. Their comments and suggestions were most helpful in the planning and preparation of this handbook.

Special acknowledgement is due Andrew Ponzini and Michael Powell, Carnegie-Mellon University students, who worked jointly with the GATF staff in the preparation of the computer programs which generated much of this handbook.

The invaluable help of the following is also acknowledged:

Guy Adams — *Harris-Intertype Corp.*
Paul E. Amelung — *International Paper Co.*
Michael H. Bruno — *International Paper Co.*
Vincent Carpano — *Oxford Paper Co.*
Thomas J. Cavallaro — *Oxford Paper Co.*
William J. Coyle — *Container Corporation*
Jonathan Dundore — *Lebanon Valley Offset Company*
Fred E. Fowler — *Capitol Printing Ink Co., Inc.*
Dr. Karl Fox — *Rapid Roller Co.*

Harold Gegenheimer — *Baldwin-Gegenheimer Corp.*
Werner Gerlach — *Capitol Printing Ink Co., Inc.*
Alex Glassman — *Consultant, Toronto, Canada*
Melvin G. Geinau — *U.S. Coast & Geodetic Survey*
Charles G. Goossen — *3M Company*
Charles Gramlich — *Los Angeles Lithographic Co.*
Willard Greenwood — *S. D. Warren – Division Scott Paper Co.*
Andrew J. Gress — *Philadelphia Lithographic Institute*
Paul R. Guy — *Schawk Graphic, Inc.*
Mohamad Hassibi — *Herbick & Held Printing Co.*
Adolf Hendler — *Consultant, New York, N. Y.*
Dr. Robert B. Hobbs — *U. S. Government Printing Office*
Dr. Frederick D. Kagy — *Illinois State University*
Charles Kennedy — *The Colonial Press, Inc.*
Neil B. Kinley — *Reid Press Limited*
Walter Lane, Jr. — *U. S. Coast & Geodetic Survey*
Lawrence Levenstein — *MLA-ALA Lithographic Technical Institute*
George W. Leyda — *3M Company*
Robert Loekle — *MLA-ALA Lithographic Institute*
John Martell — *Container Corporation*
F. J. Miller — *Kingsport Press*
Frank Oehme — *Consolidated Papers, Inc.*
Charles Olree — *Baird-Ward Printing Company*
John Pol — *Georgia-Pacific Corp.*
Raymond J. Prince — *Azoplate Corporation*
Stanley R. Rinehart — *E. I. du Pont de Nemours & Co., Inc.*
Webster C. Roberts — *Harris-Intertype Corp.*
Ted Rudla — *Container Corporation*
T. D. Schorr — *Container Corporation*
Jack Spence — *Baird-Ward Printing Company*
Philip J. Swartzbaugh — *P. H. Glatfelter Company*
Bruce E. Tory — *Leigh-Mardon Pty. Ltd.*
Louis S. Tyma — *MGD Graphic Systems*
Joseph Uhler — *Lebanon Valley Offset Company*
James R. Wood — *Standard Publishing Company*
Frank Yeager — *Lebanon Valley Offset Company*
William E. Yochheim — *The A. L. Garber Company*

Since the publication of the first edition of this *Handbook,* the authors have received many thoughtful suggestions for improving its contents, and they gratefully acknowledge this help.

A. Lavi
G. W. Jorgensen
December, 1976

Table of Contents

Introduction

The *Lithographic Pressman's Handbook* is unique in three respects. First, it is based on a GATF research project that resulted in pulling together a considerable body of immediately useful information about the lithographic press. Second, this information was stored, updated, and retrieved by means of a computer. And, third, the latest information was deliverable by the computer on demand, either as a computer print-out or a punched tape for driving a phototypesetter. This set of circumstances led to the novel design and production of the *Handbook.*

There is very little "brand new" information in the *Handbook.* The manner in which the information has been compiled is new. Shown at a glance are all the interrelationships that affect any single print quality factor. Consider, for example, the print quality factor *Ink Gloss;* any pressman knows that gloss of the dried ink film can be changed by increasing or decreasing the amount of ink feed. But practical experience as well as scientific study have clearly identified *twelve* other possible adjustments or changes which affect final ink gloss; a thirteenth possibility, whose actual effect is not as yet too clearly understood, is also available to the pressman. However, changing the ink feed will affect *twenty-three* print quality factors in addition to ink gloss. All these interrelationships are shown in chart form so that, at a glance, the skilled craftsman can identify the best possible combinations.

The format into which all this information has been assembled for publication, the thinking behind the research project for which the information was assembled, and the use of a computer to handle the storage and compilation of the interrelationships, requires terminology a bit different from the everyday language the craftsman uses. It is not necessary that the pressman use a new language; it is desirable that he understand the concepts on which these new words are based.

The word *process* has generally been used in combination with terms such as lithographic process, gravure process, letterpress process, etc. However, from the research man's point of view the whole press, and everything that goes into it, is a process — the *printing press process.* The current research project — *Printing Press Process Analysis* — concerns itself with investigating the press process as a total *system.* It is the *analysis of the total system* which will make possible *increased control* of the printing press process.

In order to think in terms of *systems analysis* it is necessary to think of the product of the process as *outputs.* The pressman's concern is with print quality. Since all the factors which affect print quality are the result of the process, the technical man thinks of them as outputs, which is exactly the way the computer can handle the interrelationships known to affect an output (print quality factor), or any number of outputs. The actions that can be taken to increase or decrease the characteristic of an output are thought of as *inputs.* As inputs, the actions that could be taken to change an output can be recorded in the memory of a computer along with all the interrelationships. In this form, new knowledge can easily be added, obsolete knowledge can be deleted, old knowledge proven to be incorrect can easily be corrected, and completely updated information quickly published.

This *Handbook* has not been published to force a new language on the craftsman. The fact is a pressman must put a job on the press, get it going to the customer's satisfaction, and run it off profitably for the plant; period. The aim of the *Lithographic Pressman's Handbook* is to make presswork a bit easier and more efficient.

How to Use the Handbook

How to Use the "Handbook"

This handbook enables the pressman to find remedies to problems normally encountered on a single-color, sheet-fed lithographic press. Because presses and pressroom practices are not the same throughout the industry, some of the suggestions made in this handbook may not apply directly in certain plants. Also, because the names given to a particular control knob or a particular print-quality differ from plant to plant, the user of this handbook should make sure that his problem is covered in the handbook by checking that the description in the handbook matches his problem. Examples of how to use this handbook to solve pressroom problems follow.

Let us suppose that our problem is PICK. That is, picking is taking place on most of our printed sheets to a degree beyond what we consider acceptable. The question is "How Can We Reduce Pick?" Note that we try to "decrease" or "reduce" but *not* get rid of Pick because there may always be some Pick.

This is the procedure to follow when using the *Handbook*.

1. Locate Pick in the list on the cover and spot the corresponding page by fanning down the edge of the book.

MOIRE PATTERNS
PICK
PLATE DRY UP

2. Read the definition on top of page 104 to make sure that the problem is indeed Pick and not something else which looks like Pick.

Pick: The delamination, splitting, or tearing of the paper surface by the resistance of the ink film to being split between blanket and paper. Picking can occur in several forms, as follows:
1. Lifting of small clumps of fibers (uncoated paper) or small flakes (coated papers) from the surface of the paper. See Figure A..
2. Lifting of large areas of fibers or coating, often with the paper splitting or tearing to the back edge of the sheet. See Figure B.
3. Blistering or delamination, sometimes with parts of the paper surface sticking to the blanket. See Figure C.

3. Identify the problem as being one of the three listed, according to the figures.

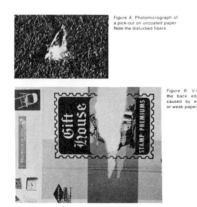

Figure A: Photomicrograph of a pick-out on uncoated paper. Note the disturbed fibers.

Figure B: V-shaped tear at the back edge of a sheet caused by either tacky ink or weak paper.

Figure C: Delamination blisters on surface of sheet caused by tacky ink of the lighter background solid.

4. If in doubt, read the section under *"Detection."*

Detection: Picking principally occurs in solids and particularly in those near the back edge of the sheets. In the case of small spots, there is a question whether they are due to pick or slitter dust. To find the cause, select a typical spot and, by thumbing down through the pile, find the sheet where it first appears. Examine the spot with a magnifier to determine if the surface of the paper shows a hole or depression. If it doesn't, the cause of the spot was a loose particle on the sheet. Blistering or delamination can be detected by viewing with a low angle light source or by touching to find if the surface feels rough.

5. Examine the "inputs" that reduce Pick. The inputs with an asterisk (*) are the easiest to manipulate. and may not even require stopping the press. Each of these inputs reduces Pick with varying degrees of effectiveness. The best solution may require changing more than one input. (See Section on Quick Reference Charts, pages 6 and 7.)

PICK

To decrease pick you have these options:

* Decrease the impression cylinder pressure.
* Decrease the ink tack.
* Decrease the press speed.
* Increase the water feed.

6. When adjusting the inputs *with the asterisk* do not produce adequate reduction of Pick, the other inputs should be tried.

These changes constitute more drastic actions, like *stopping the press, changing ink or paper,* or *informing the foreman.*

Change to a paper having greater pick resistance.
Contact the paper supplier.

7. There are other factors which, it is believed, influence Pick. However, our knowledge of these factors is incomplete at present.

The following inputs may influence pick, *but the relationship between the inputs and* pick *is not well understood at this time:*

Ink feed
Percent alcohol in fountain
Dampener chiller temperature

8. Before a decision is made as to which input to change, it is important to know the consequences of the change. Opposite each input with an asterisk is the page number where all the consequences of the input change are listed. Some of the inputs without asterisks are not referenced to a "consequences" page number. In such cases, the consequences can be identified by going to the Master Chart. (See pages 149 and 150 on how to use the Master Chart.)

PICK

To decrease pick you have these options: *FOR CONSEQUENCES SEE PAGES*

* Decrease the impression cylinder pressure 154
* Decrease the ink tack . 155
* Decrease the press speed . 156
* Increase the water feed . 157
 Change to a paper having greater pick resistance 158
 Contact the paper supplier.

This completes the description of the basic procedure for the reduction of a problem, in this case, Pick.

The Quick Reference Chart

The chart which follows the discussion of each Output (problem) and the listing of Input changes (options) for decreasing the problem is actually a summary in tabular form. It is called the Quick Reference Chart.

Illustrated below is a reproduction of the Quick Reference Chart which follows the discussion of the output (problem) Pick. The options preceded by asterisks, as listed in Step 5 on the preceding page, are the inputs and appear as headings of columns. All the outputs with which this book deals are listed in the right-hand column. Notice that the output **Pick** is in bold-face type.

The outputs are preceded by a group number. "**1**" signifies that this is an output which should be reduced or eliminated. Pick, for example, is something we always try to reduce or eliminate. "**2**" signifies that the output is one which should be increased. For example, it is almost always desirable to increase Image Sharpness. Outputs in the "**3**" group are those which we may want to *either* decrease or increase. Take, for example, the output Image Length; whether we want to increase or decrease length of the image depends on the individual circumstances of a specific run.

The symbols in each column headed by an input indicate the direction in which we want to change that input in order to achieve the desirable change in the output. The symbols are interpreted as follows:

+ Increase the Input

− Decrease the Input

‡ The Input may have to be increased or decreased

† Uncertain exactly how this input affects the Output

× Check the Input. For example: check roller adjustment; check supplier; etc.

If the main Output is in group **3**, the symbols in the Quick Reference Chart indicate the direction in which the inputs should be changed to *decrease* the six "Image_____" outputs, and to *increase* the outputs "Color reproduction," "Ink film thickness," Ink gloss," and "Tone reproduction."

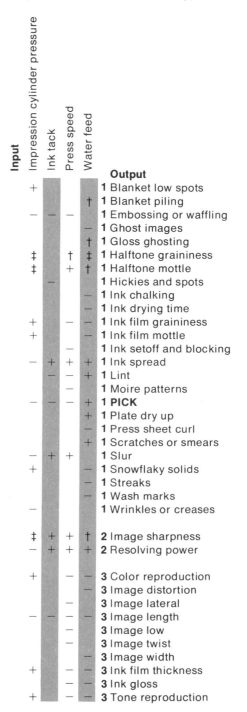

Impression cylinder pressure	Ink tack	Press speed	Water feed	Output
+				1 Blanket low spots
			†	1 Blanket piling
−	−	−		1 Embossing or waffling
			−	1 Ghost images
			†	1 Gloss ghosting
‡	†	‡	†	1 Halftone graininess
‡	+		†	1 Halftone mottle
	−			1 Hickies and spots
			−	1 Ink chalking
			−	1 Ink drying time
+	−		−	1 Ink film graininess
+			−	1 Ink film mottle
			−	1 Ink setoff and blocking
−	+	+	+	1 Ink spread
−	−		+	1 Lint
	−			1 Moire patterns
−	−	−	+	**1 PICK**
			+	1 Plate dry up
			−	1 Press sheet curl
			+	1 Scratches or smears
−	+	+		1 Slur
+			−	1 Snowflaky solids
			−	1 Streaks
			−	1 Wash marks
−				1 Wrinkles or creases
‡	+	+	†	2 Image sharpness
−	+	+	+	2 Resolving power
+		−	−	3 Color reproduction
			−	3 Image distortion
			−	3 Image lateral
−	−	−	−	3 Image length
			−	3 Image low
			−	3 Image twist
			−	3 Image width
+		−	−	3 Ink film thickness
			−	3 Ink gloss
+		−	−	3 Tone reproduction

Following is the interpretation of the Quick Reference Chart for the output "Pick." Pick will be reduced if we decrease (−) Impression Cylinder Pressure, Ink Tack, Press Speed. If we increase (+) Water Feed, we *may* reduce Pick.

This completes the elementary use of the charts.

Complex Problem Solving

While the indicated changes in any of the inputs reduces Pick, an undesirable output, some of these input changes may create other and more serious problems. So we must have the consequences of each change.

As an example, consider the problem: *Picking is exceptionally bad and the plates are critically dry.* That is, we want to reduce Pick *but* without causing further plate dry up.

Solving the Problem by Using the Text

To decide which control is best to manipulate,

1. Locate the page in the section **The Consequences,** starting on page 153, which gives the consequences of the input you want to alter; Press Speed, for instance.

2. If none of the effects of decreasing the speed produces a new problem, you decrease the speed to reduce Pick and observe the result.

3. If the reduction in speed creates other problems (such as further plate dry up), reducing impression cylinder pressure or increasing the water feed may be a better solution.

Solving the Problem by Using the Quick Reference Chart

In the quick reference chart, select the input which has no adverse consequences. This is done as follows:

1. Draw a horizontal line on all outputs (print quality factors) which are critical (Plate Dry Up and Pick).

2. Find an input which influences one output and not the other, and change it as much as necessary, or

3. Find an input which has the same sign under both lines.

In this example Pick is really bad and Plate Dry Up is critical. A possible solution is reducing the Impression Cylinder Pressure or increasing the Water Feed.

The Inputs and Their Definitions

The press inputs include the press controls and adjustments (e.g., water feed rate, ink feed rate, press speed, etc.), the fixed characteristics of the particular press (e.g., plate size, roller types, etc.), and items which are not easily varied once the press run is started (e.g., paper, ink, blanket, etc.).

The Inputs and Their Definitions

Alcohol, Percent: The amount of alcohol added to the fountain solution; primarily applicable to continuous-flow dampening systems.

Anti-Offset Spray: The combination of spray pattern on, and rate of powder flow to, the press sheet.

Blanket Compressibility: The change in the volume of the blanket under a given load.

Blanket, New: A replacement for the offset blanket on the press; either a new one, or a used one which is in good condition.

Blanket Tension: The force drawing the blanket tight to the blanket cylinder.

Contact Supplier: Some problems are best handled by consulting the supplier of the material or equipment involved (paper, ink, plate, press, etc.).

Dampener Chiller: Recirculator of fountain solution to keep the solution temperature fixed lower than the pressroom temperature.

Dampener Covers, New: New replacement covers, cloth or paper, for the dampener rollers.

Dampener Roller End-Play: Side-to-side looseness or play in dampener roller support bearings or hangers.

Dampener Roller Setting: Pressure of dampener rollers against plate, dampener vibrator roller, pan roller, etc., depending on particular dampening system.

Delivery Pile Height: The height of the paper pile in the delivery.

Guide, Front Edge: Devices which control the position (and curvature) of the front edge of the sheet before impression. Where press design permits control of curvature of front edge of sheet, there are provisions for preliminary front-edge guiding and final guiding. The latter includes means for controlling sheet curvature (bowing).

Guide, Side: Device which moves side edge of the sheet to a fixed reference line at the guide side of the feeder board or ramp.

Impression Cylinder Pressure: Pressure of impression cylinder against paper and blanket.

Ink Abrasiveness: Degree to which the pigments in the ink can wear away the plate image.

Ink Color: The hue, saturation, and lightness of the ink film.

Ink Color Strength: Relative ability of ink to give color value to paper; the pigment-to-vehicle ratio.

Ink Drier: Compounds added to the ink to complete or aid in the hardening of inks that dry by oxidation.

Ink Feed: The amount of ink delivered to the paper. This depends on the percent of a revolution that ink ductor roller remains in contact with the ink fountain roller (dwell) and the gap size between blade and ink fountain roller.

Ink Form-Roller Setting: The pressure of form rollers against plate and ink vibrator rollers.

Ink, High-Gloss: Inks which are formulated to dry with a high gloss.

Ink, New Can: Fresh, unopened can of same type or lot number of the ink.

Ink, Oxidative Drying: Oil-based inks which dry by oxidated polymerization.

Ink, Quick-Setting: Inks which set rapidly when brought into contact with the paper.

Ink Tack: Stickiness or cohesiveness of lithographic ink. Resistance of an ink film to split between two surfaces, as between rollers, between plate and blanket, and between blanket and paper.

Ink Transparency: Degree to which light is scattered and absorbed in passing through the ink film. Ink opacity is the opposite.

Paper Abrasion Resistance: The tendency of paper surface to resist being abraded in the printing process.

Paper Abrasiveness: The degree to which the paper releases abrasive materials (fibers, fillers) to the blanket. These materials then abrade the plate.

Paper Absorbency: A paper's ability to absorb or soak up fluids.

Paper Acidity: The presence in the paper of active chemicals which give an acid or base reaction.

Paper Basis Weight: Weight of ream of paper. In the United States, the basis size of a ream of book paper is 25" x 38". The "basis weight" is for 500 sheets of the basic size.

Paper Coating: Pigments in a colloidal binder applied as a thin film to the paper base stock.

Paper Color: The hue, saturation, and lightness of the paper surface.

Paper Curling Tendency: The tendency to curl due to a change in moisture balance. (Adding moisture tends to cause the paper to curl toward the felt size and with the grain.)

Paper Dimensional Stability: The expansivity of paper as percentage elongation or shrinkage caused by a given change in relative humidity or moisture content. (The size change is greater *across* than with the grain direction.)

Paper Elastic Limit: The least pull on the paper which produces permanent elongation or alteration.

Paper Flatness: The degree to which the sheet is free from wavy or tight edges, curl, and wrinkles.

Paper Formation: Uniformity of paper fiber distribution in paper; usually measured by uniformity of light transmission through a sheet of the paper.

Paper Gloss: The degree to which the paper surface resembles a perfect mirror or a highly polished surface.

Paper Grain Direction: Predominant alignment of paper fibers parallel to the direction of the wire travel on the paper machine.

Paper, Index of Refraction: The degree to which light is bent or refracted at the paper-air interface. (Not the average or gross index of refraction for the entire thickness of the paper.)

Paper, Loosely Bonded Fibers of: Fibers which are not strongly bonded to the surface of the paper.

Paper, Moisture Balance of — RH: The degree to which the moisture content is not in balance with the RH of the surrounding atmosphere. It affects the paper's tendency to become wavy or tight-edged and to change size.

Paper Moisture Resistance. Uncoated Papers: Resistance to the loosening of the paper's fibers by the plate moisture. Coated Papers: resistance to dissolving of coating by plate moisture.

Paper Opacity: Ability to hide printing on reverse side or on sheet underneath.

Paper Pick Resistance: Paper's resistance to delamination or rupture during ink-film splitting.

Paper Smoothness: The flatness of the paper surface when subjected to normal printing pressure.

Paper Straightness and Squareness: The degree to which the paper is trimmed straight and square.

Paper Surface Dust: Presence of loose particles such as mineral filler and slitter dust on the surface of the paper.

Paper Temperature: Temperature of paper in load or pile.

Paper Water Receptivity: The ease with which water wets the paper surface.

Plate Cylinder Phasing: Change in circumferential relationship of plate cylinder to blanket cylinder; adjusted by rotating the plate cylinder relative to its gear.

Plate Lateral: Distance between vertical center line of plate image to midpoint of plate cylinder axis.

Plate, New: A new replacement for the press plate.

Plate Packing Caliper: Thickness of the plate packing.

Plate Tension: The clamping force holding the plate to the plate cylinder.

Plate Twist: Angle between vertical of plate image to vertical of plate cylinder axis.

Press Speed: Linear feet per minute of plate cylinder surface travel, or cylinder revolutions per hour.

Static Eliminator: A device which prevents or readily discharges electrostatic charges on the paper.

Time Between Overprints: Time interval between successive impressions on the sheet. Affects dry trapping of successive down colors.

Water Feed: The amount of water delivered to the plate. There are two types: 1. Intermittent flow system — controls both the percent of a complete revolution that the ductor roller remains in contact with the dampener vibrator roller before returning to the pan roller (dwell), and the speed of the water pan roller. 2. Continuous flow system — controls the speed of water pan roller or brush.

Water Fountain Acidity: The hydrogen ion concentration, or pH, of the fountain solution.

Water Fountain Gums: Gums, such as gum arabic, in the fountain solution to help maintain the hydrophilic properties of the non-printing area. Aid in preventing scum.

Water Fountain Ions: Atoms or molecularly bound groups of atoms that have lost or gained one or more electrons, producing positively or negatively charged particles that are chemically reactive in the dampening process. (Influence the plate, ink, and paper performance.)

Wind Sheets: Momentary separation of the press sheets by hand riffling so that fresh air is allowed to sweep over the surface of each sheet.

Wrinkle Brush or Air Jets: Devices which flatten the press sheet to the impression cylinder before the nip.

The Outputs — Print Quality Factors

The press outputs are the dependent variables that are the effect or result of the press process. In this handbook, they are limited to the appearance attributes of the printed sheet and include such items as register, graininess, setoff, etc. These attributes are often called the print quality variables.

In this section, instructions are given for the identification and control of these outputs.

Blanket Low Spots: Areas of low ink density in the press sheet image. The caliper of the blanket in these areas is too low to develop sufficient impression pressure to plate or paper, or both. The low spots may be due to coating thickness variations in the blanket, or to previous damage to the blanket; for example, a blanket smash.

Detection: A low ink density area with a rather sharp outline usually indicates a smashed area in the blanket. Light and dark cloud-like patterns in the image areas are usually low-caliper areas in the blanket or packing. Low spots in the blanket can often be detected with a blanket thickness gauge. Turn blanket end-for-end to determine whether low areas are in blanket, plate, packing, or cylinder body.

Synonyms: Smash marks; Blanket pattern

Top: Pattern of blanket low spots due to insufficient impression cylinder pressure. *Bottom:* The same halftone tint after increasing impression cylinder pressure 0.002 inch.

The low spot in the upper corner of the square is due to a blanket smash.

*To minimize the effects of low spots in a blanket you
have these options:*

FOR CONSEQUENCES
SEE PAGES

* Increase the blanket packing caliper . 153
* Increase the impression cylinder pressure 154
* Increase the plate packing caliper . 156
* Change to a new blanket.

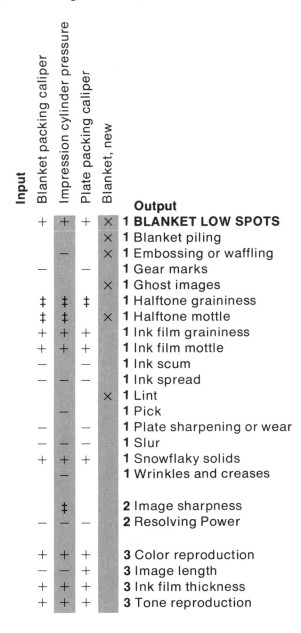

Input: Blanket packing caliper	Impression cylinder pressure	Plate packing caliper	Blanket, new	Output
+	+	+	×	**1 BLANKET LOW SPOTS**
			×	1 Blanket piling
	−		×	1 Embossing or waffling
−		−		1 Gear marks
			×	1 Ghost images
‡	‡	‡		1 Halftone graininess
‡	‡		×	1 Halftone mottle
+	+	+		1 Ink film graininess
+	+	+		1 Ink film mottle
−		−		1 Ink scum
−	−	−		1 Ink spread
			×	1 Lint
	−			1 Pick
−		−		1 Plate sharpening or wear
−	−	−		1 Slur
+	+	+		1 Snowflaky solids
	−			1 Wrinkles and creases
	‡			2 Image sharpness
−	−	−		2 Resolving Power
+	+	+		3 Color reproduction
−	−	+		3 Image length
+	+	+		3 Ink film thickness
+	+	+		3 Tone reproduction

Blanket Piling: Piling is the result of pigment or coating from the paper gradually transferring to the offset blanket and accumulating to the degree that upsets the normal impression process. This results in a lowering of the print quality. There are two types:

 1. Piling on the non-printing areas.

 2. Piling on the printing areas.

 Most piling troubles occur with coated papers if the coating lacks moisture resistance.

Detection: A white accumulation in the non-ink areas of the blanket, or a raised relief to the inked areas of the blanket indicates blanket piling. Also see "Hickies and Spots" for checking paper surface for dust.

Synonym: Coating piling

Reference: GATF's *Paper* book; pp. 84-87

Figure A: A case of paper coating piling. This is a photograph of a sheet taken at the start of the press run.

Figure B: This is a photograph of a sheet taken of the same subject as in the figure above, after 2,300 impressions, showing the effects of coating piling in the halftone printing areas.

To decrease blanket piling you have these options:

FOR CONSEQUENCES
SEE PAGES

* Increase the percent alcohol in fountain . 155
* Change to a paper having less surface dust 158
* Change to a paper having greater moisture resistance 159
 Change to a paper having greater pick resistance (if
 image area shows piling) . 158
 Change to a paper having greater abrasion resistance 161
 Change to a new blanket.
 Contact the paper supplier.

The following input may influence blanket piling, *but the relationship between the input and* blanket piling *is not well understood at this time:*

Water feed

Quick Reference Chart ▶

Photograph of an offset blanket showing piling in the non-printing areas.

Input

Percent alcohol in fountain	Paper surface dust	Paper moisture resistance	Output
+	−	+	**1 BLANKET PILING**
†			1 Embossing or waffling
+			1 Ghost images
†		+	1 Halftone graininess
†		+	1 Halftone mottle
	−		1 Hickies and spots
†	−	+	1 Ink film graininess
+	−	+	1 Ink spread
†			1 Pick
+			1 Plate dry up
+		+	1 Slur
		+	1 Snowflaky solids
†			2 Resolving power
†			3 Color reproduction
+			3 Image width
†			3 Tone reproduction

COLOR REPRODUCTION ▶

Color Reproduction: Relationship between the colors of corresponding areas in the standard — the original copy, proof, or OK sheet — and in a press sheet pulled for inspection. This relationship can be described by comparing three attributes of the color in each area:

1. The hue — denoting that it is a red, blue, yellow, etc;
2. The saturation — denoting the depth of the color;
3. The lightness — denoting its equivalent gray.

Detection: Place the press sheet and standard alongside each other on an inspection table illuminated by a north window, or by a light fixture designed for the appraisal of color uniformity. View the colors on the perpendicular to estimate the color match or uniformity, as shown below. The appraisal can also be made using a colorimeter; for details consult manufacturers' literature. (See also: Ink Gloss; Ink Film Thickness; Tone Reproduction.)

References: GATF's *Paper* book; pp. 171-173
GATF Research Progress No. 79; No. 81

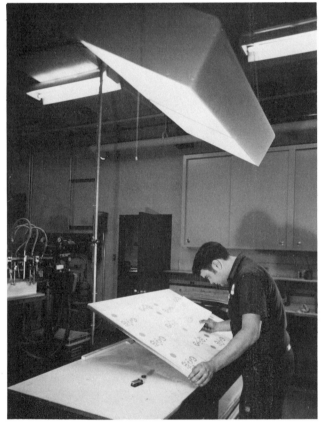

Pressman is holding OK standard in his right hand and checking color reproduction of stepped images on inspection sheet.

*To increase the saturation and decrease the lightness
(and in overprint areas to shift the hue toward the color
in your ink fountain) you have these options:*

FOR CONSEQUENCES
SEE PAGES

* Increase the blanket packing caliper. 153
* Increase the impression cylinder pressure. 154
* Increase the ink feed. 155
* Increase the plate packing caliper. 156
* Decrease the press speed . 156
* Decrease the water feed. 157
* Check the ink color.
 Change to a paper having less absorbency 158
 Change to a paper having more smoothness 159
 Change to a paper having a lower index of refraction. 160
 Change to a paper having more gloss. 161
 Change to a higher color strength ink. 161
 Contact the ink supplier.
 Change to a paper of more suitable color.
 Change to a high-gloss ink.
 Change to a blanket having less compressibility. 162
 Change to a new plate.

The following inputs may influence color reproduction, *but
the relationship between the inputs and* color reproduction *is
not well understood at this time:*

 Percent alcohol in fountain
 Water fountain ions
 Water fountain gums ***Quick Reference Chart*** ◗

Input

Blanket packing caliper	Impression cylinder pressure	Ink feed	Plate packing caliper	Press speed	Water feed	Ink color	Output
+	+		+				**1** Blanket low spots
					†		**1** Blanket piling
	−			−			**1** Embossing or waffling
−			−				**1** Gear marks
		+			−		**1** Ghost images
		†			†		**1** Gloss ghosting
‡	‡	‡	‡	†	‡		**1** Halftone graininess
‡	‡	−		+	†		**1** Halftone mottle
		†			−		**1** Ink chalking
		−			−		**1** Ink drying time
+	+	+	+	−	−		**1** Ink film graininess
+	+	+	+		−		**1** Ink film mottle
−		−					**1** Ink scum
		−		−			**1** Ink setoff and blocking
−	−	−		+	+		**1** Ink spread
		†		−	+		**1** Lint
				−			**1** Moire patterns
	−	†		−	+		**1** Pick
		−			+		**1** Plate dry up
−			−				**1** Plate sharpening or wear
					−		**1** Press sheet curl
		−			+		**1** Scratches or smears
		−					**1** Show through
−	−	−	−	+			**1** Slur
+	+	+	+	−			**1** Snowflaky solids
					−		**1** Streaks
		+			−		**1** Wash marks
−							**1** Wrinkles or creases
	‡	+		+	†		**2** Image sharpness
	−	−	−	+	+		**2** Resolving power
+	+	+	+	−	−	×	**3 COLOR REPRODUCTION**
					−		**3** Image distortion
				−			**3** Image lateral
−	−		+	−	−		**3** Image length
				−			**3** Image low
				−			**3** Image twist
					−		**3** Image width
+	+	+	+	−	−		**3** Ink film thickness
		+		−	−		**3** Ink gloss
+	+	+	+	−	−		**3** Tone reproduction

DOUBLING ▶

Doubling: In single-color presswork, doubling occurs when the press sheet prematurely slaps against the blanket upon going into the nip. This results in a weak transfer of the ink from the blanket which is slightly out of register with the full image transferred in the nip between the blanket and impression cylinder.

Detection: Doubling usually makes the halftones appear darker and the dots elongated (Figure A). A grid-like moire pattern sometimes appears in the halftone (see Figure A, under Moire). If doubling occurs in a Star Target, a figure eight will appear in its center (Figure B). Doubling will often be localized to some areas of the sheet, especially if it is due to tight- or wavy-edged paper.

Synonym: Dot doubling

References: GATF's *Advanced Pressmanship* book pp. 76, 128, 261
GATF Research Progress No. 52 (Revised 1970)

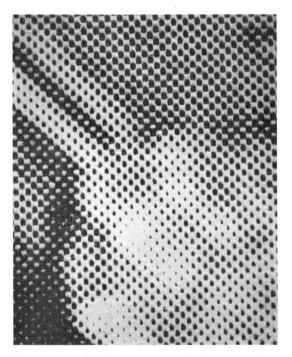 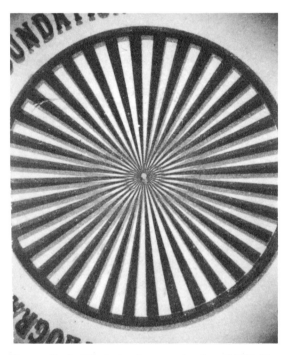

Figure A: A 10X photomicrograph of a press sheet halftone showing doubling. Notice elongation of dots.

Figure B: A 6X photomicrograph of a GATF Star Target from the same press sheet as Figure A. Notice the figure-eight center due to doubling.

To decrease doubling you have these options:

FOR CONSEQUENCES
SEE PAGES

* Increase the blanket tension. 153
* Increase the wrinkle brush or air-jet pressure 158

Input		Output
Blanket tension	Wrinkle brush pressure	
+	+	**1 DOUBLING**
+		**1** Halftone graininess
+		**1** Ink scum
+		**1** Ink spread
+	+	**1** Moire patterns
+		**1** Slur
+		**1** Streaks
	+	**1** Wrinkles or creases
+	+	**2** Image sharpness
+	+	**2** Resolving power
+	+	**3** Image distortion

Dry Ink Trap: The degree to which a wet ink film will transfer or adhere over the dried, previously printed ink films on the press sheet. When poor trapping occurs, the inks of the previous down colors are said to have "crystallized," but the actual effect is due to non-drying oils which "sweat out" of the dried films and prevent adherence of the wet ink.

Detection: A solid on the plate transfers as a continuous ink film to the bare paper but only in spots or in a broken, wormy pattern on the previous down color. Examine over-printed solids with a magnifier.

Synonyms: Ink crystallization; Ink crawling

Reference: GATF's *Ink* book; pp. 93, 154-155

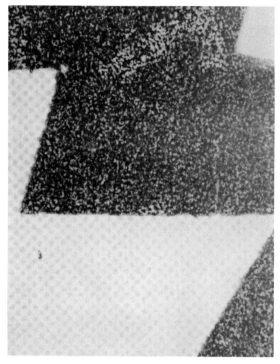

An 8X photomicrograph of poor trapping of a black ink over a light-color ink which had "crystallized."

A 64X photomicrograph of the black ink film in the figure at left.

To increase dry ink trap you have these options:

FOR CONSEQUENCES
SEE PAGES

* Decrease the anti-offset spray 153
* Decrease the time between overprints (this applies
 to oxidative drying ink only) 157
 Contact the ink supplier.
 Change to a quicker-setting ink.

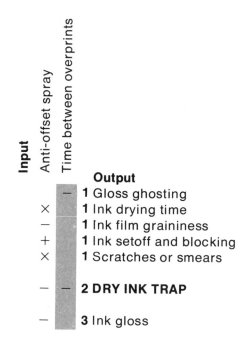

Input

Anti-offset spray
Time between overprints

Output

−	−	**1** Gloss ghosting
×		**1** Ink drying time
−		**1** Ink film graininess
+		**1** Ink setoff and blocking
×		**1** Scratches or smears
−	−	**2 DRY INK TRAP**
−		**3** Ink gloss

Embossing-Waffling: Image areas (usually the solids) of the printed paper are raised above other areas. This is caused by the pull of the ink as the paper is peeled off the blanket following the impression. Embossing-waffling occurs when printing thin, relatively weak paper (Figure A). On label sheets carrying solid bands of color, this is sometimes referred to as waffling. Back-edge curl is due to the same causes as embossing.

Detection: View surface of sheet at a low angle toward a light source. Embossed areas appear as a high relief. For back-edge curl, hang sheet by gripper edge and note if tail of sheet has a sharp hook as in Figure B.

Synonyms: Tail-end hook; Back-edge curl; Relief images

Reference: GATF's *Paper* book; pp. 24, 37, 38, 78, 82, 94, 96, 122, 198

Figure A: Skid of lightweight printed stock showing embossing of solid areas.

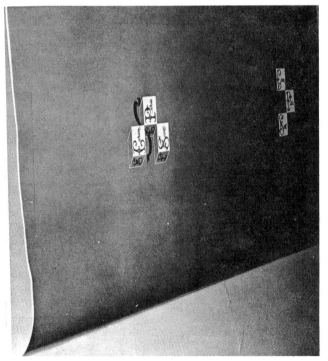

Figure B: Example of back-edge curl due to the solid extending to the back of the sheet.

To decrease embossing or waffling you have these options: FOR CONSEQUENCES
SEE PAGES

The following inputs may influence embossing-waffling, *but
the relationship between the inputs and* embossing-waffling
is not well understood at this time:

Percent alcohol in fountain
Ink, oxidative drying
Ink, quicker-setting

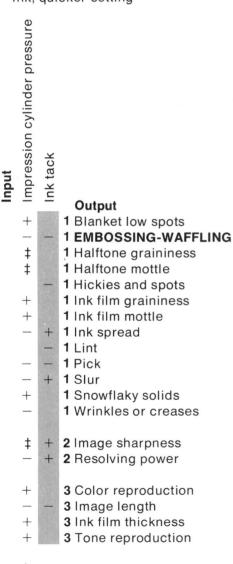

Input
Impression cylinder pressure
Ink tack

		Output
+		**1** Blanket low spots
−	−	**1 EMBOSSING-WAFFLING**
‡		**1** Halftone graininess
‡		**1** Halftone mottle
	−	**1** Hickies and spots
+		**1** Ink film graininess
+		**1** Ink film mottle
−	+	**1** Ink spread
	−	**1** Lint
−	−	**1** Pick
−	+	**1** Slur
+		**1** Snowflaky solids
−		**1** Wrinkles or creases
‡	+	**2** Image sharpness
−	+	**2** Resolving power
+		**3** Color reproduction
−	−	**3** Image length
+		**3** Ink film thickness
+		**3** Tone reproduction

Gear Marks: Alternate light and dark marks as bands in halftones and solids. They are parallel to the gripper edge of the sheet. The distance between marks is uniform and equal.

Detection: Using a flexible steel ruler, measure distances between marks in print and the spacing of teeth on the plate cylinder gear. To be characterized as gear marks, the two measurements should be about equal, as shown in the figure below.

Reference: GATF's *Press Troubles* book; pp. 25, 26

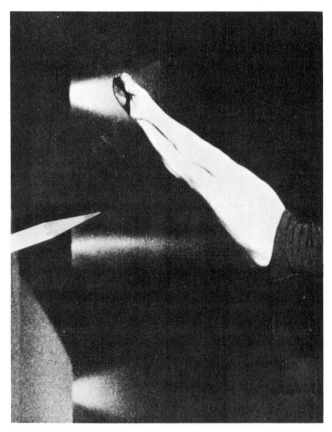

Press sheet showing gear marks. Notice the spacing of the marks: they are more apparent in the darker tone areas.

To decrease gear marks you have these options:

FOR CONSEQUENCES
SEE PAGES

* Decrease the blanket packing caliper........................ 153
* Decrease the plate packing caliper......................... 156
* Change to a more compressible blanket..................... 162
 Contact the press manufacturer.

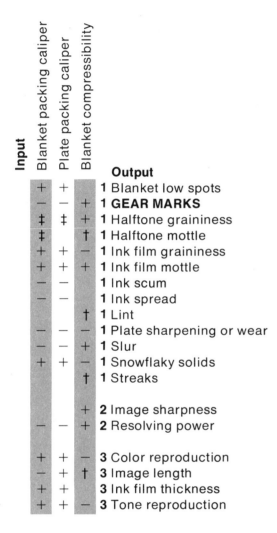

Input

Blanket packing caliper	Plate packing caliper	Blanket compressibility	Output
+	+		**1** Blanket low spots
−	−	+	**1 GEAR MARKS**
‡	‡	+	**1** Halftone graininess
‡		†	**1** Halftone mottle
+	+	−	**1** Ink film graininess
+	+	+	**1** Ink film mottle
−	−		**1** Ink scum
−	−		**1** Ink spread
		†	**1** Lint
−	−	−	**1** Plate sharpening or wear
−	−	+	**1** Slur
+	+	−	**1** Snowflaky solids
		†	**1** Streaks
		+	**2** Image sharpness
−	−	+	**2** Resolving power
+	+	−	**3** Color reproduction
−	+	†	**3** Image length
+	+		**3** Ink film thickness
+	+	−	**3** Tone reproduction

Ghost Images: The ink film on the press sheet shows abrupt variations in thickness or color which correspond to a weak image or multiple weak images of other printed areas in the around-the-cylinder direction.

Detection: Examine press sheet at normal viewing distance and look for light and dark patterns in the image that repeat from gripper to trailing edge of sheet, as shown in the figure below.

Synonyms: Mechanical ghosts; Starvation patterns

Reference: GATF's *Ink* book; pp. 159, 160

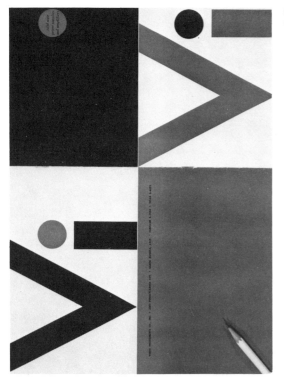

Ghost images of the 'Vi' on the white background (top) repeating in the solid (bottom)

To decrease ghost images you have these options:

FOR CONSEQUENCES
SEE PAGES

* Increase the ink feed. 155
* Increase the percent alcohol in fountain. 155
* Decrease the water feed . 157
 Change the blanket.
 Contact the ink supplier.
 Contact the press manufacturer.
 Change to an ink having less transparency.

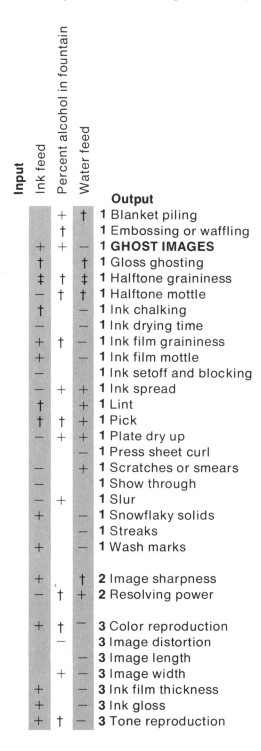

Ink feed	Percent alcohol in fountain	Water feed		Output
	+	†	**1**	Blanket piling
	†		**1**	Embossing or waffling
+	+	−	**1**	**GHOST IMAGES**
†		†	**1**	Gloss ghosting
‡	†	‡	**1**	Halftone graininess
−	†	†	**1**	Halftone mottle
†		−	**1**	Ink chalking
−		−	**1**	Ink drying time
+	†	−	**1**	Ink film graininess
+		−	**1**	Ink film mottle
−			**1**	Ink setoff and blocking
−	+	+	**1**	Ink spread
†		+	**1**	Lint
†	†	+	**1**	Pick
−	+	+	**1**	Plate dry up
		−	**1**	Press sheet curl
−		+	**1**	Scratches or smears
−			**1**	Show through
−	+		**1**	Slur
+		−	**1**	Snowflaky solids
		−	**1**	Streaks
+		−	**1**	Wash marks
+		†	**2**	Image sharpness
−	†	+	**2**	Resolving power
+	†	−	**3**	Color reproduction
	−		**3**	Image distortion
		−	**3**	Image length
	+	−	**3**	Image width
+		−	**3**	Ink film thickness
+		−	**3**	Ink gloss
+	†	−	**3**	Tone reproduction

Gloss-Ghosting: Image printed on one side of the sheet appears as gloss variations in the ink film on the reverse side.

Detection: Gloss-ghosts do not appear until several hours after printing. Select press sheets from bottom of skid and visually examine the ink film from a low angle for presence of gloss-ghost images, as shown in figures.

Reference: GATF Research Progress No. 72

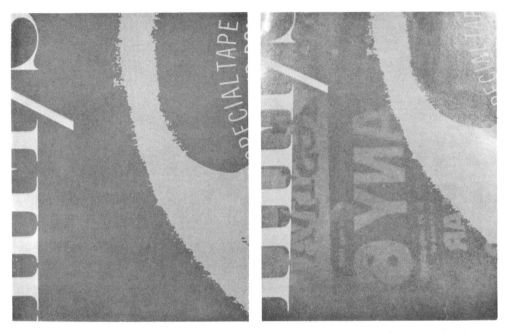

Two views of a press sheet having gloss-ghosts. The view at the left was made with the illumination at 45 degrees to the surface. The view at the right was made with the illumination at about 20 degrees to the surface in order to bring out the gloss ghosts which correspond to the printing on the reverse side of the sheet.

To reduce gloss ghosting you have these options:

FOR CONSEQUENCES
SEE PAGES

* Reduce time between overprints. 157
* Wind sheets in pile. 157
* Contact the paper supplier.
* Contact the ink supplier.

The following inputs may influence gloss ghosting, *but the relationship between the inputs and* gloss ghosting *is not well understood at this time:*

Delivery pile height
Ink driers
Ink feed
Water feed
Water fountain acidity
Paper absorbency
Paper acidity
Paper smoothness
Paper moisture content
Ink, oxidative drying
Ink, quicker-setting
Ink, high-gloss
Water fountain ions

Input Time between overprints	Wind sheets	Contact paper supplier	Contact ink supplier	**Output**
	×			**1** Blanket piling
			×	**1** Ghost images
−	×	×	×	**1 GLOSS GHOSTING**
			×	**1** Ink chalking
	+		×	**1** Ink drying time
		×	×	**1** Ink film graininess
		×		**1** Ink film mottle
			×	**1** Ink setoff and blocking
			×	**1** Ink spread
		×		**1** Lint
		×		**1** Pick
		×		**1** Show through
			×	**2** Dry ink trap
			×	**2** Resolving power
			×	**3** Color reproduction

Halftone Graininess: A grainy or sandpaper-like appearance in what should be a smooth, even tone value in a halftone. Caused by random, microscopic irregularities and imperfections in the halftone dots, as shown in the figures below.

Detection: Examine the halftone dots with a magnifier and try to determine which of the factors below, alone or in combination, are causing the grainy appearance.
1. Hickies and spots
2. Wash marks
3. Ink scum
4. Snowflaky solids
5. Plate sharpening
6. Blanket piling
7. Plate dry up
8. Doubling
9. Ink spread
10. Slur
11. Ink film graininess

Synonyms: Salt-and-pepper; Sandpapery; Rough halftones; Smoothness of printing.

References: GATF Research Progress No. 34; No. 36

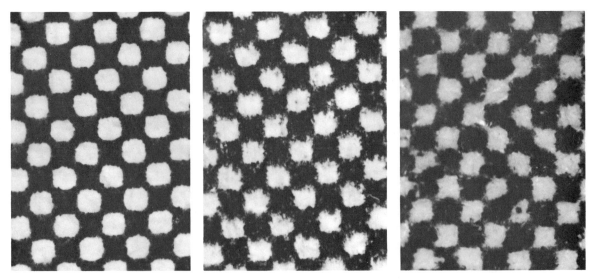

Photomicrographs of halftones showing (from left to right) increasing graininess.

To reduce halftone graininess you have these options:

The following inputs may influence halftone graininess, *but
the relationship between the inputs and* halftone graininess
is not well understood at this time:

Percent alcohol in fountain
Press speed
Ink, oxidative drying
Water fountain ions
Water fountain gums
Dampener chiller temperature

Quick Reference Chart ▶

Input

Blanket packing caliper	Blanket tension	Dampener roller setting to plate	Form roller setting to the plate	Impression cylinder pressure	Ink feed	Plate packing caliper	Water feed	Output
+				+		+		**1** Blanket low spots
							†	**1** Blanket piling
	+							**1** Doubling
				−				**1** Embossing or waffling
−				−				**1** Gear marks
					+		−	**1** Ghost images
					†		†	**1** Gloss ghosting
‡	+	×	×	‡	‡	‡	‡	**1 HALFTONE GRAININESS**
‡	+	×	×	‡	−		†	**1** Halftone mottle
					†		−	**1** Ink chalking
							−	**1** Ink drying time
+			+		+	+	−	**1** Ink film graininess
+			+		+	+	−	**1** Ink film mottle
−	+	×	×				−	**1** Ink scum
					−			**1** Ink setoff and blocking
−	+		×		−	−	+	**1** Ink spread
					†		+	**1** Lint
	+							**1** Moire patterns
				−	†		+	**1** Pick
		×	×		−		+	**1** Plate dry up
		×	×				−	**1** Plate sharpening or wear
							−	**1** Press sheet curl
					−		+	**1** Scratches or smears
					−			**1** Show through
−	+		−		−	−		**1** Slur
+			+		+	+	−	**1** Snowflaky solids
	+	×	×				−	**1** Streaks
					+		−	**1** Wash marks
							−	**1** Wrinkles or creases
	+			‡	+		†	**2** Image sharpness
−	+	×	×		−	−	+	**2** Resolving power
+				+	+	+	−	**3** Color reproduction
	+						−	**3** Image distortion
−				−		+	−	**3** Image length
							−	**3** Image width
+			×	+	+	+	−	**3** Ink film thickness
					+		−	**3** Ink gloss
+				+	+	+	−	**3** Tone reproduction

HALFTONE MOTTLE ◗

Halftone Mottle: Blotchy or cloud-like patterns in what should be smooth tone values in halftone tints. Caused by large, random variations in ink gloss, density, and dot sizes.

Detection: At normal viewing distance, locate a flat tone area in the original and its corresponding image in the press sheet. Look for blurs or swirl-like patterns in the press sheet area which indicate mottle patterns.

 Mottle patterns may be due to:

1. Uneven impression pressures — check blanket and packing sheets for caliper variations (Figure A).
2. Caliper variations in the paper — check for wild formation by viewing strong light source through sheet (Figure B).
3. Uneven absorption of ink by the paper (see 2 above).
4. Piling on blanket (Figure C).

Reference: GATF's *Ink* book; pp. 144, 145

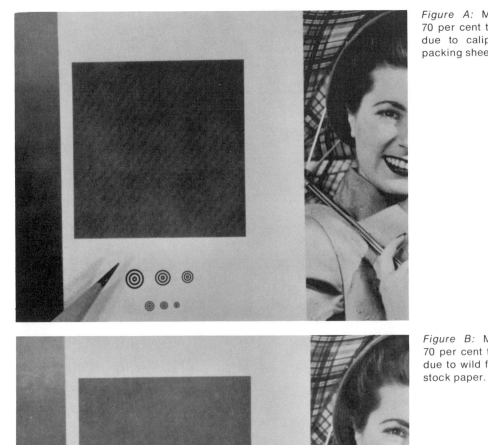

Figure A: Mottle pattern in 70 per cent tint (square area) due to caliper variations in packing sheets.

Figure B: Mottle pattern in 70 per cent tint (square area) due to wild formation in a tag stock paper.

To decrease halftone mottle you have these options:

* Increase the blanket packing caliper (if blanket low
 spots or snowflaky solids are present). 153
* Decrease the blanket packing caliper (if halftone
 dots show spread or slur) . 153
* Increase the impression cylinder pressure (if
 blanket low spots or snowflaky solids are present) 154
* Decrease the impression cylinder pressure (if
 halftone dots show spread or slur). 154
* Decrease the ink feed (if dots show spread). 155
* Increase the press speed (if dots show spread). 156
 Check the dampener roller settings
 Check the form roller settings.
 Change to a paper having greater moisture resistance
 (if blanket shows piling). 159
 Change to a paper having less wild formation 161
 Change to a new blanket.

The following inputs may influence halftone mottle, *but the
relationship between the inputs and* halftone mottle *is not
well understood at this time:*

 Percent alcohol in fountain
 Water feed
 Ink, oxidative drying
 Ink, quicker-setting
 Ink, high-gloss
 Water fountain ions
 Blanket compressibility

Quick Reference Chart ♦

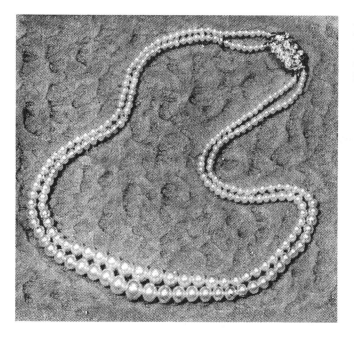

Figure C: Mottle pattern due
to coating pile on the blanket.
(See Figure A on page 16 for
appearance before mottle
pattern developed.)

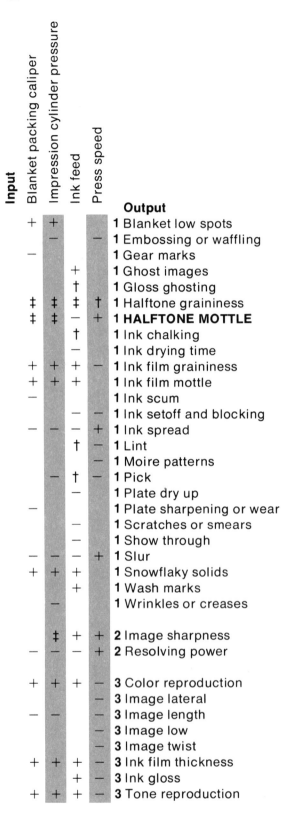

Input				Output
Blanket packing caliper	Impression cylinder pressure	Ink feed	Press speed	
+	+			**1** Blanket low spots
	−		−	**1** Embossing or waffling
−				**1** Gear marks
		+		**1** Ghost images
		†		**1** Gloss ghosting
‡	‡	‡	†	**1** Halftone graininess
‡	‡	−	+	**1** HALFTONE MOTTLE
		†		**1** Ink chalking
		−		**1** Ink drying time
+	+	+	−	**1** Ink film graininess
+	+	+		**1** Ink film mottle
−				**1** Ink scum
		−	−	**1** Ink setoff and blocking
		−	+	**1** Ink spread
		†	−	**1** Lint
			−	**1** Moire patterns
	−	†	−	**1** Pick
		−		**1** Plate dry up
−				**1** Plate sharpening or wear
		−		**1** Scratches or smears
		−		**1** Show through
−	−	−	+	**1** Slur
+	+	+		**1** Snowflaky solids
		+		**1** Wash marks
	−			**1** Wrinkles or creases
	‡	+	+	**2** Image sharpness
−	−	−	+	**2** Resolving power
+	+	+	−	**3** Color reproduction
			−	**3** Image lateral
−	−		−	**3** Image length
			−	**3** Image low
			−	**3** Image twist
+	+	+	−	**3** Ink film thickness
		+	−	**3** Ink gloss
+	+	+	−	**3** Tone reproduction

HICKIES AND SPOTS ▶

Hickies and Spots: Randomly scattered spots, usually in the printed solids. Once a spot appears it recurs in the same place on succeeding sheets. Two types of spots are most common:
1. Hickies consisting of small solid areas, sharply defined and surrounded by white halos (Figure A).
2. Small white "spots," sometimes showing a more or less distinct fiber pattern (Figure B).

The first are caused by solid particles that stick to the plate or blanket and are ink receptive; e.g. ink skins, chips of roller composition, flakes of paint, etc. The second, or "spots," are usually attributed to the paper: loose cutter or slitter dust, small clumps of fibers picked from the surface of uncoated paper, particles of the paper coating, etc.

Detection: Examine with magnifying glass to identify as 1 or 2 above. Riffle through the sheets in the pile to see if spot remains in same position. If type 2, check if first sheet showing spot has a crater; this will identify that the cause is picking of the paper surface (see Pick). If no crater is present, the cause is probably surface dust. Check by wiping unprinted sheets with a black velvet or felt cloth and examine the cloth for presence of excessive amount of white material. An alternate method is to scan over the surface of the unprinted sheets with a low angle light source (pen flashlight) and a 20X magnifying glass (see Figure C).

Synonyms: Spots; Dirt, Chips; Half-moons; Donuts; Feathers; Tracks; Eggs; Lint; Buckshot

References: GATF's *Paper* book; pp. 81-84
GATF Tech Service Report Vol. 3, No. 3

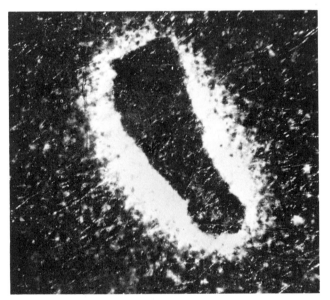

Figure A: Photomicrograph of a typical ink skin hicky.

To decrease hickies and spots you have these options:

FOR CONSEQUENCES
SEE PAGES

* Decrease the ink tack 155
* Change to a paper having less surface dust................... 158
* Change to a new can of ink (if hickies are due to
 ink skins, see Figure A).

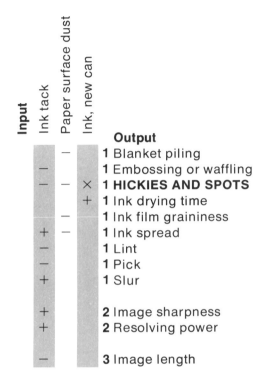

Input			Output
Ink tack	Paper surface dust	Ink, new can	
	−		**1** Blanket piling
−			**1** Embossing or waffling
−	−	×	**1** HICKIES AND SPOTS
		+	**1** Ink drying time
	−		**1** Ink film graininess
+	−		**1** Ink spread
−			**1** Lint
−			**1** Pick
+			**1** Slur
+			**2** Image sharpness
+			**2** Resolving power
−			**3** Image length

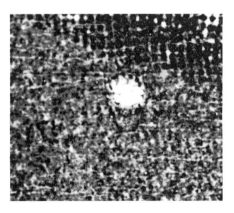

Figure B: Greatly enlarged photo of a typical hicky caused by a loose particle of paper, several sheets after it first appeared.

Figure C: Photomicrograph of lint and loose foreign particles on surface of paper; illuminated at a low angle.

Image Distortion: Curvature of the press sheet image relative to the plate image.

Detection: The width between register marks at the gripper and trailing edges are not equal when compared to the marks on the plate. If the press sheet marks are wider at the gripper edge, the distortion is "keystone" as shown in Figure A. If the press sheet marks are wider at the trailing edge, the distortion is "fan-out" as shown in Figure B.

Reference: GATF's *Paper* book; pp. 33, 87-91

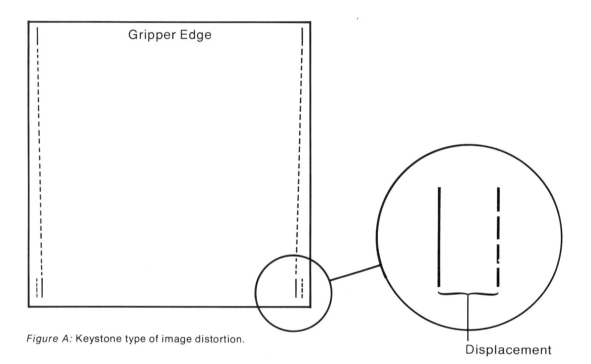

Figure A: Keystone type of image distortion.

Displacement

To decrease image distortion you have these options: FOR CONSEQUENCES
SEE PAGES

Quick Reference Chart ▶

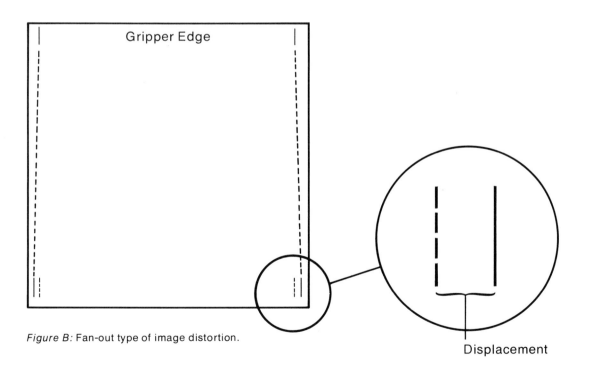

Figure B: Fan-out type of image distortion.

Displacement

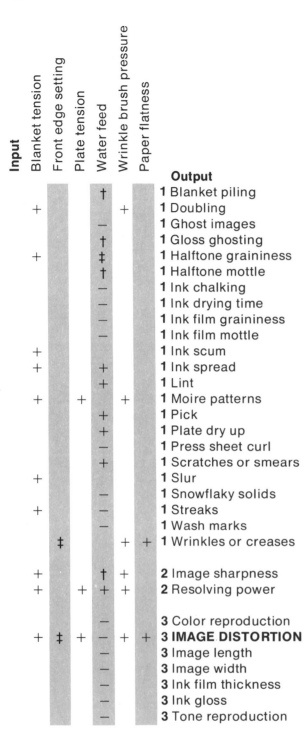

Input	Blanket tension	Front edge setting	Plate tension	Water feed	Wrinkle brush pressure	Paper flatness	Output
				†			**1** Blanket piling
	+				+		**1** Doubling
				−			**1** Ghost images
				†			**1** Gloss ghosting
	+			‡			**1** Halftone graininess
				†			**1** Halftone mottle
				−			**1** Ink chalking
				−			**1** Ink drying time
							1 Ink film graininess
							1 Ink film mottle
	+						**1** Ink scum
	+			+			**1** Ink spread
				+			**1** Lint
	+		+		+		**1** Moire patterns
				+			**1** Pick
				+			**1** Plate dry up
				−			**1** Press sheet curl
				+			**1** Scratches or smears
	+						**1** Slur
				−			**1** Snowflaky solids
	+			−			**1** Streaks
				−			**1** Wash marks
		‡			+	+	**1** Wrinkles or creases
	+			†	+		**2** Image sharpness
	+		+	+	+		**2** Resolving power
				−			**3** Color reproduction
	+	‡	+	−	+	+	**3** IMAGE DISTORTION
				−			**3** Image length
				−			**3** Image width
				−			**3** Ink film thickness
				−			**3** Ink gloss
				−			**3** Tone reproduction

IMAGE LATERAL ▶

Image Lateral: Image prints too close to, or too far from, the side-guide edge of the press sheet.

Detection: Fold press sheet so that corners of the gripper edge exactly coincide and then carefully crease the sheet. If center line marks do not fall on the crease the image requires a lateral shift to bring it into fit (Figure A). The center line can also be checked on a line-up table (Figure C) following manufacturers' instructions. Center line marks of successive-down colors should print on those of the first-down color (Figure B).

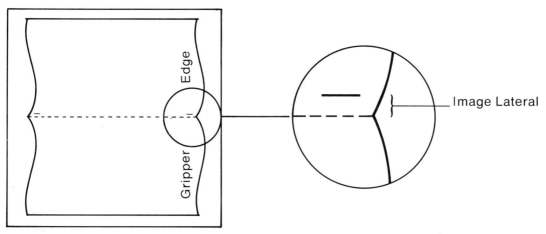

Figure A: Fold sheet down center to check if center line is on crease.

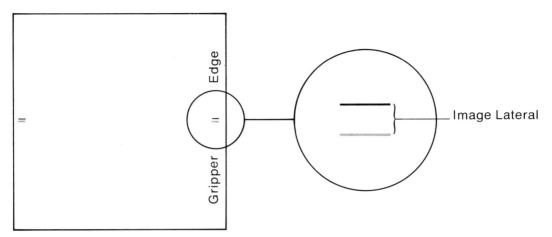

Figure B: Center line of successive-down colors should coincide with center line of the first-down color.

To decrease image lateral you have these options: FOR CONSEQUENCE
 SEE PAGE

* Adjust the plate laterally on the plate cylinder.
* Adjust the side guide settings.
 Decrease the press speed 156

Output

× × **3 IMAGE LATERAL**

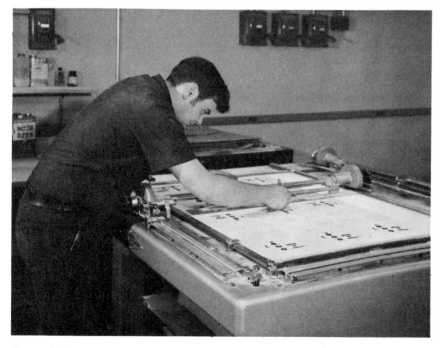

Figure C: Checking center line on a line-up table.

Image Length: The distance between the register marks of each color on the press sheet measured from the gripper to the trailing edge.

Detection: Measure distance between register marks on gripper and trailing edges of press sheet (Figure A). On successive-down colors, compare register mark of second-down color to marks of first-down color (Figure B).

Figure A: Image length is the distance between register marks at gripper and trailing edges.

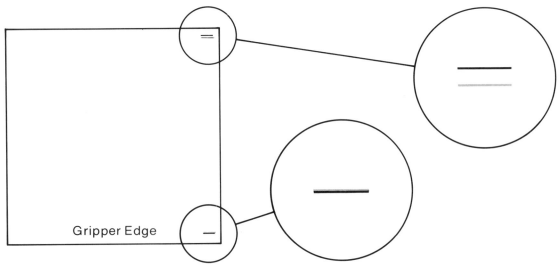

Figure B: Register marks of successive-down colors should coincide with first-down color. Here, second color is short.

To decrease image length you have these options:

The following input may influence image length, *but the
relationship between the input and* image length *is not well
understood at this time:*

Blanket compressibility

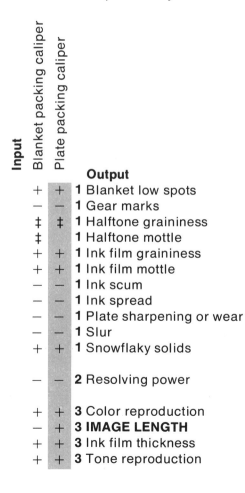

Input		Output
Blanket packing caliper	Plate packing caliper	
+	+	**1** Blanket low spots
−	−	**1** Gear marks
‡	‡	**1** Halftone graininess
‡		**1** Halftone mottle
+	+	**1** Ink film graininess
+	+	**1** Ink film mottle
−	−	**1** Ink scum
−	−	**1** Ink spread
−	−	**1** Plate sharpening or wear
−	−	**1** Slur
+	+	**1** Snowflaky solids
−	−	**2** Resolving power
+	+	**3** Color reproduction
−	+	**3 IMAGE LENGTH**
+	+	**3** Ink film thickness
+	+	**3** Tone reproduction

Image Low: Image prints too far back from, or too close to, gripper edge of press sheet.

Detection: Measure distance from trim marks to edge of sheet at both gripper and trailing edge. There should be sufficient margin at each edge for proper trimming in the bindery, as shown in Figure A. (Check binder's, instructions on trim tolerances.) A line-up table can also be used to check position (see manufacturers instructions). On successive-down colors the gripper and trailing edge marks are below (or above) those of the first-down color (Figure B).

Figure A: Measure distance from trim marks to edge of sheet for trim tolerances.

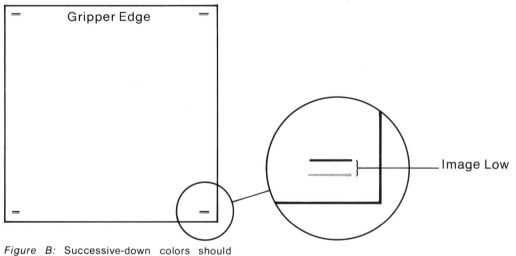

Figure B: Successive-down colors should register to marks of first-down color.

To change gripper-edge margin you have these options:

* Change the plate cylinder lead edge forward or back FOR CONSEQUENCES
 in relation to the plate cylinder gear. *SEE PAGES*

Decrease the press speed 156

Input
Plate cylinder moved forward

Output
× **3 IMAGE LOW**

Image Sharpness: The clarity of fine detail and distinctness of edges in the image when examined at normal viewing distance.

Detection: This is not a well understood variable even though it is often noticed and commented on during both makeready and press run. Some of the causes of poor sharpness to look for are: low resolution in the halftones (see Resolving Power); large amounts of internal light scatter in the paper (see Paper, Index of Refraction); insufficient ink (see Ink Film Thickness); low gloss (see Ink Gloss); and tone reproduction (see Tone Reproduction).

Synonyms: Crispness; Snap

References: GATF's *Paper* book; pp. 53-54
 GATF Research Progress No. 47; No. 52

The same halftone printed on uncoated (left) and coated (right) paper. Detail generally appears sharper and brighter on the coated paper.

To increase image sharpness you have these options: FOR CONSEQUENCES
SEE PAGES

The following inputs may influence image sharpness, *but
the relationship between the inputs and* image sharpness
is not well understood at this time:

Water feed
Water fountain acidity
Ink, oxidative drying
Ink, quicker-setting
Ink, high-gloss
Water fountain ions
Water fountain gums ***Quick Reference Chart ▶***

Input: Blanket tension	Impression cylinder pressure	Ink feed	Ink tack	Press speed	Wrinkle brush pressure	Output
	+					**1** Blanket low spots
+					+	**1** Doubling
	−		−	−		**1** Embossing or waffling
		+				**1** Ghost images
		†				**1** Gloss ghosting
+	‡	‡		†		**1** Halftone graininess
	‡	−		+		**1** Halftone mottle
			−			**1** Hickies and spots
		†				**1** Ink chalking
		−				**1** Ink drying time
	+	+		−		**1** Ink film graininess
	+	+				**1** Ink film mottle
+						**1** Ink scum
		−		−		**1** Ink setoff and blocking
+	−	−	+	+		**1** Ink spread
		†	−	−		**1** Lint
+				−	+	**1** Moire patterns
	−	†	−	−		**1** Pick
		−				**1** Plate dry up
		−				**1** Scratches or smears
		−				**1** Show through
+	−	−	+	+		**1** Slur
	+	+				**1** Snowflaky solids
+						**1** Streaks
		+				**1** Wash marks
	−				+	**1** Wrinkles or creases
+	‡	+	+	+	+	**2 IMAGE SHARPNESS**
+	−	−	+	+	+	**2** Resolving power
	+	+		−		**3** Color reproduction
+					+	**3** Image distortion
				−		**3** Image lateral
	−		−	−		**3** Image length
				−		**3** Image low
				−		**3** Image twist
	+	+		−		**3** Ink film thickness
		+		−		**3** Ink gloss
	+	+		−		**3** Tone reproduction

IMAGE TWIST ▸

Image Twist: The horizontal lines in the image are not parallel to the gripper edge of the sheet.

Detection: In fitting the image to the sheet, fold press sheet so that corners of gripper edge exactly coincide. View register marks through folded sheet. If one register mark is closer to the gripper edge than the other it indicates plate is twisted, or cocked, and must be rotated to square-up the image to the press sheet. (See Figure A). A line-up table may also be used to check position.

In registering to a previous-down color, if the two register marks at the gripper corners are not equally high or low to the gripper line marks of the first-down color, the plate is twisted or cocked. See Figure B.

Reference: GATF's *Advanced Pressmanship* book; pp. 75-76

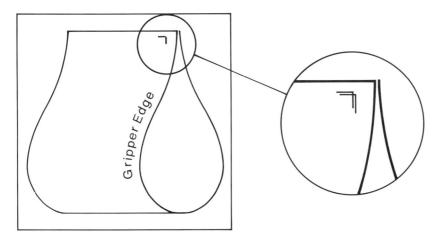

Figure A: Fold sheet and view gripper edge marks through sheet over a strong light source.

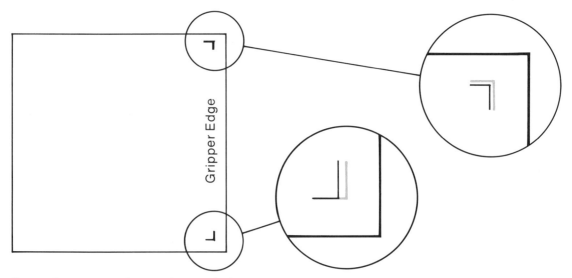

Figure B: If one gripper edge mark is higher than the other — relative to the marks of the first-down color — the plate is cocked or twisted.

*To parallel the horizontal lines in the image to the gripper
edge of the sheet you have these options:*

FOR CONSEQUENCES
SEE PAGE

* Change the plate position on cylinder.
Decrease the press speed . 156

Input
Plate twist

Output
✕ **3 IMAGE TWIST**

Image Width: Horizontal distance (measured parallel to gripper edge) between the register marks for each color.

Detection: Measure distance across sheet between the register or trim marks (Figure A). For good register of successive-down colors, the width of the trailing-edge marks of the first-down color should be the same as the marks on the plate (Figure B). See GATF Research Progress No. 54 for use of the GATF Register Rule.

Reference: GATF Research Progress No. 54

Figure A: For first-down color, trailing edge marks should have same width on plate and press sheet.

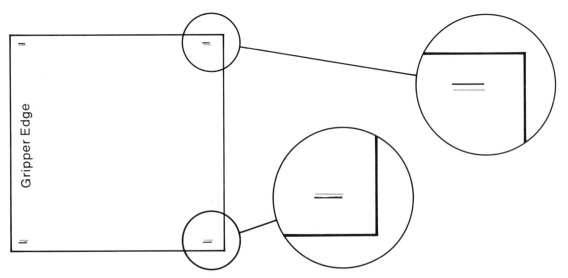

Figure B: Successive-down colors should coincide with those of the first-down color. Here, the second color is not wide enough.

To decrease image width you have these options:

Input			Output
Percent alcohol in fountain	Water feed		
+	†	**1**	Blanket piling
†		**1**	Embossing-waffling
+	−	**1**	Ghost images
	†	**1**	Gloss ghosting
†	‡	**1**	Halftone graininess
†	†	**1**	Halftone Mottle
	−	**1**	Ink chalking
	−	**1**	Ink drying time
†	−	**1**	Ink film graininess
	−	**1**	Ink film mottle
+	+	**1**	Ink spread
	+	**1**	Lint
+	+	**1**	Pick
+	+	**1**	Plate dry up
	−	**1**	Press sheet curl
	+	**1**	Scratches-smear
+		**1**	Slur
	−	**1**	Snowflaky solids
	−	**1**	Streaks
	−	**1**	Wash marks
	†	**2**	Image sharpness
†	+	**2**	Resolving power
†	−	**3**	Color reproduction
	−	**3**	Image distortion
	−	**3**	Image length
+		**3**	**IMAGE WIDTH**
	−	**3**	Ink film thickness
	−	**3**	Ink gloss
†	−	**3**	Tone reproduction

Ink Chalking: Ink can easily be rubbed off even though it has set on the paper and no longer sets off when the sheets are handled or backed up. Occurs mainly on coated papers.

Detection: Rub ink film using firm pressure on finger — ink will easily rub off, as shown below.

Reference: GATF's *Paper* book; pp. 102-104

Excessive absorption of ink vehicle due to retarded drying caused this ink film to chalk. Note the light areas where the ink was rubbed off.

To decrease ink chalking you have these options:

FOR CONSEQUENCES
SEE PAGES

* Decrease the water feed .. 157
* Decrease the water fountain acidity .. 157
 Increase the ink driers .. 154
 Change to a paper having a lower acidity 159
 Contact the ink supplier.
 Change to a quicker-setting ink.
 Change to a high-gloss ink.

The following inputs may influence image chalking, *but
the relationship between the inputs and* image chalking *is
not well understood at this time:*

 Ink feed
 Water fountain ions

Quick Reference Chart ▶

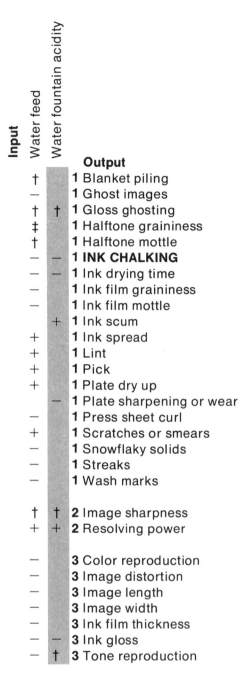

Input	Water feed	Water fountain acidity	Output
	†		**1** Blanket piling
	−		**1** Ghost images
	†	†	**1** Gloss ghosting
	‡		**1** Halftone graininess
	†		**1** Halftone mottle
	−	−	**1 INK CHALKING**
	−	−	**1** Ink drying time
	−		**1** Ink film graininess
	−		**1** Ink film mottle
		+	**1** Ink scum
	+		**1** Ink spread
	+		**1** Lint
	+		**1** Pick
	+		**1** Plate dry up
		−	**1** Plate sharpening or wear
	−		**1** Press sheet curl
	+		**1** Scratches or smears
	−		**1** Snowflaky solids
	−		**1** Streaks
	−		**1** Wash marks
	†	†	**2** Image sharpness
	+	+	**2** Resolving power
	−		**3** Color reproduction
	−		**3** Image distortion
	−		**3** Image length
	−		**3** Image width
	−		**3** Ink film thickness
	−	−	**3** Ink gloss
	−	†	**3** Tone reproduction

INK DRYING TIME ♦

Ink Drying Time: Time required for the wet ink film on the press sheet to form a relatively tack-free and smudge-resistant surface.

Detection: Place a finger on an image area, and with a light and steady pressure draw it across the sheet. If the ink does not smudge, it is dry enough for handling. Like most methods of deciding when the ink is tack-free enough for the press sheet to receive the next press impression, or to be sent to the bindery, the finger test is very subjective in nature and requires some experience to get reproducible results.

Reference: GATF's *Ink* book; pp. 137-143

The degree of ink drying can be estimated by the smudge produced when rubbing a finger across the edge of a solid.

To decrease ink drying time you have these options:

The following inputs may influence ink drying time, *but the relationship between the inputs and* ink drying time *is not well understood:*

Water fountain ions
Water fountain gums

Quick Reference Chart ♦

Input

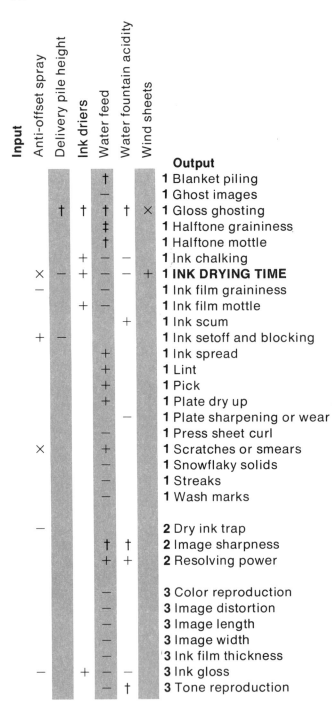

Anti-offset spray	Delivery pile height	Ink driers	Water feed	Water fountain acidity	Wind sheets	Output
			†			**1** Blanket piling
			−			**1** Ghost images
	†	†	†	†	×	**1** Gloss ghosting
			‡			**1** Halftone graininess
			†			**1** Halftone mottle
		+	−	−		**1** Ink chalking
×	−	+	−	−	+	**1 INK DRYING TIME**
−						**1** Ink film graininess
		+	−			**1** Ink film mottle
				+		**1** Ink scum
+	−					**1** Ink setoff and blocking
			+			**1** Ink spread
			+			**1** Lint
			+			**1** Pick
			+			**1** Plate dry up
			−			**1** Plate sharpening or wear
			−			**1** Press sheet curl
×			+			**1** Scratches or smears
			−			**1** Snowflaky solids
			−			**1** Streaks
			−			**1** Wash marks
−						**2** Dry ink trap
			†	†		**2** Image sharpness
			+	+		**2** Resolving power
			−			**3** Color reproduction
			−			**3** Image distortion
			−			**3** Image length
			−			**3** Image width
			−			**3** Ink film thickness
−		+	−	−		**3** Ink gloss
			−	†		**3** Tone reproduction

INK FILM GRAININESS ◗

Ink Film Graininess: Rough or sandpaper-like appearance in what should be a smooth, continuous ink film on the press sheet.

Detection: View press sheet at normal viewing distance and look for fine grain-like patterns in the solids.

Examine the ink film with a magnifier, looking for very small irregularities such as holes, uncovered paper fibers, fine worm-like wrinkles in the ink, etc., as shown in the figures below. (See also Ink Film Mottle, Snowflaky Solids.)

Synonyms: Sandpaper solids; Rough solids; Grainy ink film

Reference: GATF's *Ink* book; p. 145

Photomicrographs, at 12X, of ink films having low graininess (left), moderate graininess (center), and high graininess (right).

To decrease ink film graininess you have these options: FOR CONSEQUENCES
SEE PAGES

The following input may influence ink film graininess, *but
the relationship between the input and* ink film graininess *is
not well understood at this time:*

Percent alcohol in fountain ***Quick Reference Chart*** ◗

Input

Anti-offset spray	Blanket packing caliper	Impression cylinder pressure	Ink feed	Plate packing caliper	Press speed	Water feed	Output
	+	+		+			**1** Blanket low spots
						†	**1** Blanket piling
		−			−		**1** Embossing or waffling
	−			−			**1** Gear marks
			+			−	**1** Ghost images
			†			†	**1** Gloss ghosting
	‡	‡	‡	‡	†	‡	**1** Halftone graininess
	‡	‡	−	‡	+	†	**1** Halftone mottle
			†			−	**1** Ink chalking
×			−			−	**1** Ink drying time
−	+	+	+	+	−	−	**1 INK FILM GRAININESS**
	+	+	+	+		−	**1** Ink film mottle
	−			−			**1** Ink scum
+			−			−	**1** Ink setoff and blocking
	−	−	−	−	+	+	**1** Ink spread
			†		−	+	**1** Lint
					−		**1** Moire patterns
		−	†		−	+	**1** Pick
			−			+	**1** Plate dry up
	−			−			**1** Plate sharpening or wear
						−	**1** Press sheet curl
×		−				+	**1** Scratches or smears
			−				**1** Show through
	−	−	−	−	+		**1** Slur
	+	+	+	+		−	**1** Snowflaky solids
						−	**1** Streaks
		+				−	**1** Wash marks
		−					**1** Wrinkles or creases
−							**2** Dry ink trap
		‡	+		+	†	**2** Image sharpness
	−	−	−	−	+	+	**2** Resolving power
	+	+	+	+	−	−	**3** Color reproduction
						−	**3** Image distortion
						−	**3** Image lateral
	−	−	+	−		−	**3** Image length
						−	**3** Image low
						−	**3** Image twist
						−	**3** Image width
	+	+	+	+	−	−	**3** Ink film thickness
−			+		−	−	**3** Ink gloss
	+	+	+	+	−	−	**3** Tone reproduction

INK FILM MOTTLE ◗

Ink Film Mottle: Blotchy, cloudy, or galvanized appearance in what should appear as a smooth, continuous ink film on the press sheet. Mottle patterns are random rather than symmetrical, and each blotch is approximately 1/8 inch to 3/8 inch in diameter. Mottle can be caused by papers which are not uniformly absorbent or that have a "wild" formation. It can also be caused by press conditions.

Detection: There are two types of mottle patterns:
1. Those due to uneven transfer of the ink film.
2. Those due to gloss variations in the ink surface.

The first type can be detected by examining light and dark blotches with a magnifier to determine if there are variations in film thickness, as shown below. The second type can be detected by viewing the ink film at a low angle to a light source (see Ink Gloss).

Synonyms: Unevenness; Galvanized solids

References: GATF's *Paper* book; pp. 86, 104
　　　　　　　GATF's *Ink* book; p. 144

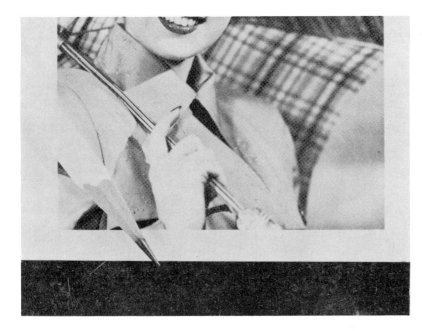

Mottle patterns in solid on uncoated paper. Compare with pencil for size of pattern.

To decrease ink film mottle you have these options:

The following inputs may influence ink film mottle, *but
the relationship between the inputs and* ink film mottle
is not well understood at this time:

 Ink, oxidative drying
 Ink, quicker-setting
 Ink, high-gloss
 Water fountain ions

Quick Reference Chart ▸

Input						Output
Blanket packing caliper	Impression cylinder pressure	Ink driers	Ink feed	Plate packing caliper	Water feed	
+	+				+	**1** Blanket low spots
					†	**1** Blanket piling
	−					**1** Embossing or waffling
−			−			**1** Gear marks
			+		−	**1** Ghost images
		†	†		†	**1** Gloss ghosting
‡	‡		‡	‡	‡	**1** Halftone graininess
‡	‡		−		†	**1** Halftone mottle
		+	†		−	**1** Ink chalking
		+	−			**1** Ink drying time
+	+		+	+	−	**1** Ink film graininess
+	+	+	+	+	−	**1 INK FILM MOTTLE**
−			−			**1** Ink scum
			−			**1** Ink setoff and blocking
−	−		−	−	+	**1** Ink spread
			†		+	**1** Lint
	−		†		+	**1** Pick
			−		+	**1** Plate dry up
−			−			**1** Plate sharpening or wear
					−	**1** Press sheet curl
			−		+	**1** Scratches or smears
			−			**1** Show through
−	−		−	−		**1** Slur
+	+		+	+	−	**1** Snowflaky solids
					−	**1** Streaks
			+		−	**1** Wash marks
	−					**1** Wrinkles or creases
	‡		+		†	**2** Image sharpness
−	−		−	−	+	**2** Resolving power
+	+		+	+	−	**3** Color reproduction
					−	**3** Image distortion
−				+	−	**3** Image length
					−	**3** Image width
+	+		+	+	−	**3** Ink film thickness
		+	+		−	**3** Ink gloss
+	+		+	+	−	**3** Tone reproduction

INK FILM THICKNESS ▸

Ink Film Thickness: The thickness of the ink film transferred to the press sheet.

Detection: The ink film thickness can be crudely estimated by lightly drawing the finger over a wet, freshly printed sheet, as shown below. A thick ink film may cause smudging and also indicates the tendency to set off. Another method is to measure a solid on the press sheet through a polarized light densitometer with a filter complementary to the color of the ink. However, this method can only be used where the color strengths of the inks are known. (See also Color Reproduction.)

References: GATF's *Ink* book; pp. 98, 134
GATF Research Progress No. 66

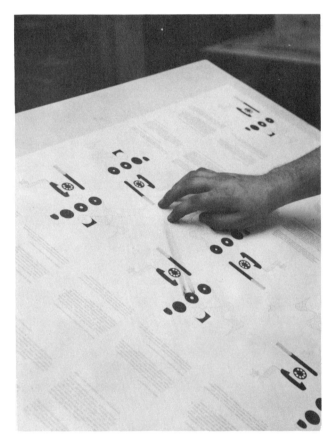

The two smudge streaks, produced by lightly sweeping the fingers across the wet press sheet, may indicate an excessive ink film thickness and a tendency to setoff.

To increase ink film thickness you have these options: FOR CONSEQUENCES
SEE PAGES

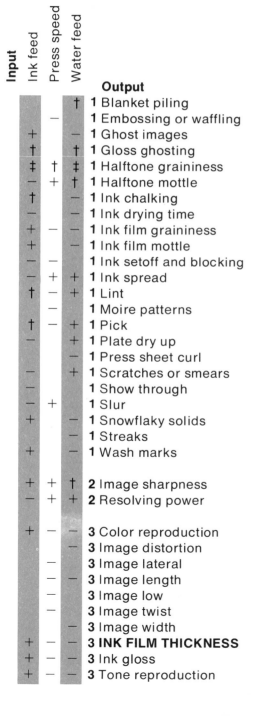

Input: Ink feed	Press speed	Water feed	Output
		†	**1** Blanket piling
	−		**1** Embossing or waffling
+		−	**1** Ghost images
†		†	**1** Gloss ghosting
‡	†	‡	**1** Halftone graininess
−	+	†	**1** Halftone mottle
†		−	**1** Ink chalking
−		−	**1** Ink drying time
+	−	−	**1** Ink film graininess
+		−	**1** Ink film mottle
−		−	**1** Ink setoff and blocking
−	+	+	**1** Ink spread
†	−	+	**1** Lint
	−		**1** Moire patterns
†	−	+	**1** Pick
−		+	**1** Plate dry up
		−	**1** Press sheet curl
−		+	**1** Scratches or smears
−			**1** Show through
	+		**1** Slur
+		−	**1** Snowflaky solids
		−	**1** Streaks
+		−	**1** Wash marks
+	+	†	**2** Image sharpness
−	+	+	**2** Resolving power
+	−	−	**3** Color reproduction
		−	**3** Image distortion
	−		**3** Image lateral
	−	−	**3** Image length
	−		**3** Image low
	−		**3** Image twist
		−	**3** Image width
+	−	−	**3 INK FILM THICKNESS**
+	−	−	**3** Ink gloss
+	−	−	**3** Tone reproduction

Ink Gloss: Degree to which the surface of the film on the press sheet resembles a mirror or a highly polished surface.

Detection: The gloss of an ink film can usually be estimated by viewing its surface at a low angle when facing a distant light source, as shown below. In this manner one can estimate the degree of specular reflectance as well as the texture of the film surface. Glossmeters are also available, but the interpretation of their readings must be made with discretion (see manufacturer's instructions). The gloss of the ink film usually decreases on drying and is called "dry back."

Reference: GATF's *Ink* book; pp. 116, 176-177

Viewing press sheet surface at a low angle toward a distant light source. Notice specular reflection of the light near the pressman's right hand.

To increase ink gloss you have these options:

FOR CONSEQUENCES
SEE PAGES

The following input may influence ink gloss, *but the relationship between the input and* ink gloss *is not well understood at this time:*

Water fountain ions

Quick Reference Chart ▶

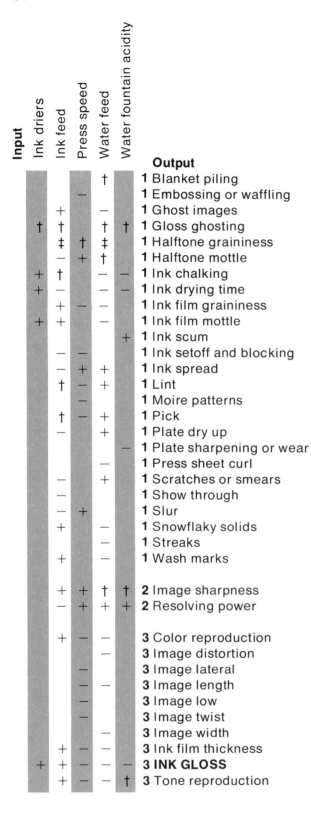

Ink driers	Ink feed	Press speed	Water feed	Water fountain acidity	Output
			†		**1** Blanket piling
		−			**1** Embossing or waffling
	+	−			**1** Ghost images
†	†		†	†	**1** Gloss ghosting
	‡	†	‡		**1** Halftone graininess
	−	+	†		**1** Halftone mottle
+	†			−	**1** Ink chalking
+	−			−	**1** Ink drying time
	+	−			**1** Ink film graininess
+	+	−			**1** Ink film mottle
				+	**1** Ink scum
	−	−			**1** Ink setoff and blocking
	−	+	+		**1** Ink spread
	†	−	+		**1** Lint
		−			**1** Moire patterns
	†	−	+		**1** Pick
	−		+		**1** Plate dry up
				−	**1** Plate sharpening or wear
			−		**1** Press sheet curl
	−		+		**1** Scratches or smears
	−				**1** Show through
	−	+			**1** Slur
	+		−		**1** Snowflaky solids
			−		**1** Streaks
	+		−		**1** Wash marks
	+	+	†	†	**2** Image sharpness
	−	+	+	+	**2** Resolving power
	+	−	−		**3** Color reproduction
			−		**3** Image distortion
		−			**3** Image lateral
		−	−		**3** Image length
		−			**3** Image low
		−			**3** Image twist
			−		**3** Image width
	+	−	−		**3** Ink film thickness
+	+	−	−	−	**3 INK GLOSS**
	+	−	−	†	**3** Tone reproduction

INK SCUM ▸

Ink Scum: The non-image areas of the plate lose their desensitization and begin to take ink.

Detection: The ink in the non-image areas cannot be washed off with plain water but will usually clean up when given a wet-wash and etch, or when treated with the plate manufacturers' plate cleaner or conditioner. On aluminum plates, scum sometimes appears as a multitude of fine, sharp dots when viewed under a magnifier. (See also Plate Dry Up.)

Reference: GATF's *Advanced Pressmanship* book; pp. 243-247

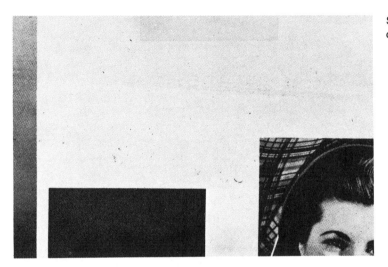

Scum due to plate's losing its desensitization.

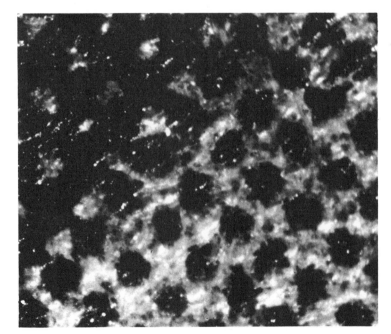

Photomicrograph of oxidation (ink dot) scum between dots on an aluminum plate.

To decrease ink scum you have these options:

FOR CONSEQUENCES
SEE PAGES

* Reduce blanket packing caliper. 153
* Increase the blanket tension. 153
* Check the dampener roller settings to the plate.
* Check the form roller settings.
* Reduce plate packing caliper. 156
* Increase the water fountain acidity . 157
* Change to a paper having less abrasiveness 160
* Increase the water fountain gums. 162
* Change to a new plate.
* Change the dampener covers.

The following inputs may influence ink scum, *but the relationship between the inputs and* ink scum *is not well understood at this time:*

 Ink, oxidative drying
 Ink, quicker-setting
 Ink, high gloss
 Water fountain ions

Quick Reference Chart ▸

Input

Blanket packing caliper	Blanket tension	Dampener roller setting to plate	Form roller setting to the plate	Plate packing caliper	Water fountain acidity	Paper abrasiveness	Water fountain gums	Plate, new	Dampener covers, new	Output
+				+						1 Blanket low spots
	+									1 Doubling
−				−						1 Gear marks
					†					1 Gloss ghosting
‡	+	×	×	‡		−	†		×	1 Halftone graininess
‡		×	×							1 Halftone mottle
					−					1 Ink chalking
					−		†			1 Ink drying time
+				+						1 Ink film graininess
+				+						1 Ink film mottle
−	+	×	×	−	+	−	+	×	×	**1 INK SCUM**
−	+		×	−						1 Ink spread
									×	1 Lint
	+									1 Moire patterns
		×	×						×	1 Plate dry up
−		×	×	−	−	−	†		×	1 Plate sharpening or wear
−	+			−						1 Slur
+				+						1 Snowflaky solids
	+	×	×							1 Streaks
	+				†		†		×	2 Image sharpness
−	+	×	×	−	+		†		×	2 Resolving power
+				+			†		×	3 Color reproduction
	+									3 Image distortion
−				+						3 Image length
+			×	+						3 Ink film thickness
					−					3 Ink gloss
+				+	†		†		×	3 Tone reproduction

INK SETOFF AND BLOCKING ▸

Ink Setoff and Blocking: Wet ink on the surface of the sheets transferring or sticking to the backs of following sheets in the delivery pile.

Detection: Examine backs of sheets (facing the freshly printed side) in the delivery pile for traces of ink transferred from the wet sheet, particularly at sides and tail end of sheet. Blocking occurs when the wet ink causes the sheets to stick together.

Synonym: Offsetting

Reference: GATF's *Paper* book; pp. 96-99

Photograph of ink setoff on the back of a press sheet which faced a heavy solid on the printed side of the sheet.

A 12X photomicrograph of an area on the sheet in the upper figure.

To decrease ink setoff and blocking you have these options:

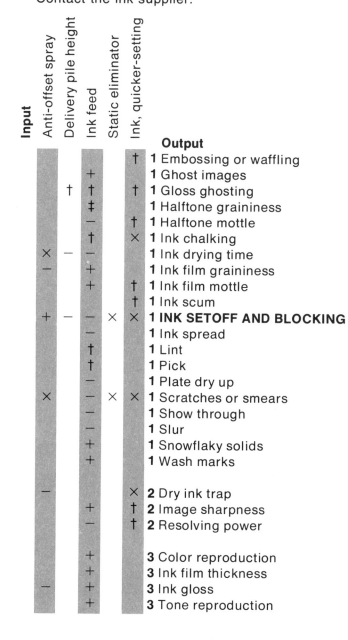

Input

Anti-offset spray	Delivery pile height	Ink feed	Static eliminator	Ink, quicker-setting	Output
				†	**1** Embossing or waffling
		+			**1** Ghost images
	†	†		†	**1** Gloss ghosting
		‡			**1** Halftone graininess
				†	**1** Halftone mottle
		†		×	**1** Ink chalking
×	−	−			**1** Ink drying time
−		+			**1** Ink film graininess
		+		†	**1** Ink film mottle
				†	**1** Ink scum
+	−	−	×	×	**1 INK SETOFF AND BLOCKING**
		−			**1** Ink spread
		†			**1** Lint
		†			**1** Pick
		−			**1** Plate dry up
×		−	×	×	**1** Scratches or smears
		−			**1** Show through
		−			**1** Slur
		+			**1** Snowflaky solids
		+			**1** Wash marks
−				×	**2** Dry ink trap
		+		†	**2** Image sharpness
		−		†	**2** Resolving power
		+			**3** Color reproduction
		+			**3** Ink film thickness
−		+			**3** Ink gloss
		+			**3** Tone reproduction

Ink Spread: The edges of the ink dots and lines on the press sheet spreading in all directions beyond their corresponding areas on the plate. This enlargement may take place on the plate, and in image transfer to the blanket or paper.

Detection: Ink spread is usually more noticeable in the middle tones and shadows of halftones. Check by viewing corresponding dot areas of plate and press sheet with a 10X magnifying glass. It also can be detected if a GATF Star Target has been printed on the sheet — spread causes the wedges to close to a solid at the center of the target.

Synonyms: Greasing; Dot spread; Dot gain

References: GATF's *Ink* book; pp. 145, 148
GATF Research Progress No. 52, Figure 4

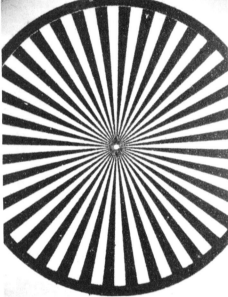

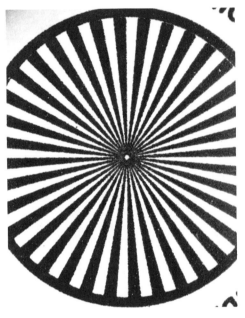

An 8X photomicrograph of a GATF Star Target printed on enamel paper. The absence of a solid at its center indicates that very little ink spread is present.

An 8X photomicrograph of a GATF Star Target on enamel paper. The dark solid at the center indicates considerable ink spread is present.

To decrease ink spread you have these options: FOR CONSEQUENCES
 SEE PAGES

Quick Reference Chart ▶

Input

Blanket packing caliper	Blanket tension	Impression cylinder pressure	Ink feed	Ink tack	Percent alcohol in fountain	Plate packing caliper	Press speed	Water feed	Output
+		+				+			**1** Blanket low spots
					+			†	**1** Blanket piling
	+								**1** Doubling
		−	−		†		−		**1** Embossing or waffling
−						−			**1** Gear marks
			+		+			−	**1** Ghost images
			†					†	**1** Gloss ghosting
‡	+	‡	‡		†	‡	†	‡	**1** Halftone graininess
‡	‡	−			†	+		†	**1** Halftone mottle
			−						**1** Hickies and spots
					†			−	**1** Ink chalking
					−			−	**1** Ink drying time
+		+	+		†	+	−	−	**1** Ink film graininess
+		+	+			+		−	**1** Ink film mottle
	+					−			**1** Ink scum
						−		−	**1** Ink setoff and blocking
−	+	−	−	+	+	−	+	+	**1. INK SPREAD**
			†	−				+	**1** Lint
	+					−			**1** Moire patterns
		−	†	−	†	−		+	**1** Pick
			−		+			+	**1** Plate dry up
						−			**1** Plate sharpening or wear
								−	**1** Press sheet curl
			−					+	**1** Scratches or smears
			−						**1** Show through
−	+	−	−	+	+	−	+		**1** Slur
+		+	+			+		−	**1** Snowflaky solids
	+							−	**1** Streaks
			+					−	**1** Wash marks
									1 Wrinkles or creases
	+	‡	+	+			+	†	**2** Image sharpness
−	+	−	−	+	†	−	+	+	**2** Resolving power
+		+	+		†	+	−	−	**3** Color reproduction
	+								**3** Image distortion
							−		**3** Image lateral
−	−	−				+	−	−	**3** Image length
							−		**3** Image low
							−		**3** Image twist
				+					**3** Image width
+		+	+			+		−	**3** Ink film thickness
			+					−	**3** Ink gloss
+		+	+		+	+	−	−	**3** Tone reproduction

LINT ▶

Lint: Linting mainly occurs on uncoated papers and is caused by fibers that are only partly bonded to the surface of the sheet. The loosely bonded fibers are picked up by the blanket. If the fiber is lifted from an image area, it leaves a fiber-shaped un-inked print (Figure A). After a few impressions, these images usually disappear, and the fibers tend to accumulate on the inking rollers. With continued running, the ink becomes so contaminated with fibers that the press has to be stopped and washed up. (Also see Hickies.)

Detection: Linting, if it occurs, is usually more apparent on the wire side of the sheet. The presence of lint, fuzz, or whiskers on the paper may not be evident from a superficial examination. To detect them, bend a sheet of the paper sharply and examine the bend (after lightly rubbing with a finger) using a magnifier as shown in Figures B and C. Lint can also be caused by worn or defective dampener covers. However, since cotton fibers are longer than wood fibers (more than one-eighth inch long), an examination with a magnifier will identify if the lint is from the paper or the dampener.

Synonyms: Fuzz; Fluff; Whiskers

Reference: GATF's *Paper* book; pp. 46-47, 162

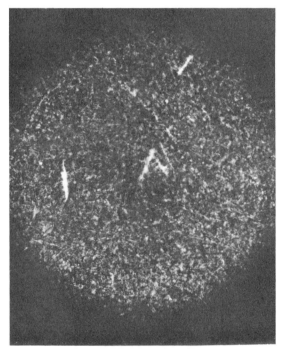

Figure A: Photomicrograph of lint marks in a solid.

To decrease lint you have these options:

The following inputs may influence lint, *but the relationship between the inputs and* lint *is not well understood at this time:*

Ink feed
Blanket compressibility

Quick Reference Chart ▶

Figure B: Photomicrograph of a linty paper

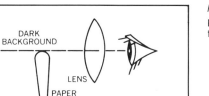

Figure C: Diagram showing paper surface being examined for lint.

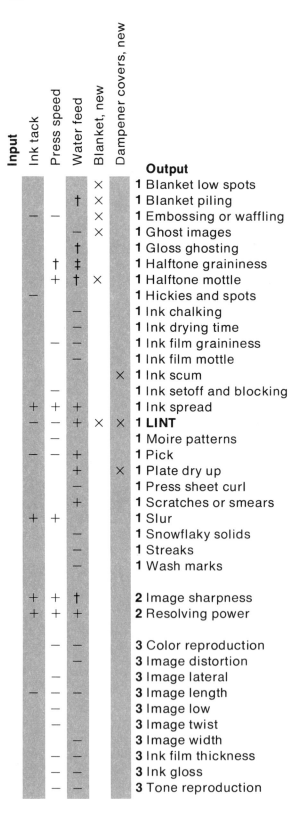

Input	Ink tack	Press speed	Water feed	Blanket, new	Dampener covers, new	Output
				×		**1** Blanket low spots
			†	×		**1** Blanket piling
	−	−		×		**1** Embossing or waffling
			−	×		**1** Ghost images
			†			**1** Gloss ghosting
		†	‡			**1** Halftone graininess
		+	†	×		**1** Halftone mottle
	−					**1** Hickies and spots
			−			**1** Ink chalking
			−			**1** Ink drying time
		−	−			**1** Ink film graininess
			−			**1** Ink film mottle
					×	**1** Ink scum
	−					**1** Ink setoff and blocking
	+	+	+			**1** Ink spread
	−	−	+	×	×	**1 LINT**
		−				**1** Moire patterns
	−	−	+			**1** Pick
			+		×	**1** Plate dry up
			−			**1** Press sheet curl
			+			**1** Scratches or smears
	+	+				**1** Slur
			−			**1** Snowflaky solids
			−			**1** Streaks
			−			**1** Wash marks
	+	+	†			**2** Image sharpness
	+	+	+			**2** Resolving power
		−				**3** Color reproduction
		−				**3** Image distortion
			−			**3** Image lateral
	−	−	−			**3** Image length
		−				**3** Image low
		−				**3** Image twist
						3 Image width
		−	−			**3** Ink film thickness
		−	−			**3** Ink gloss
		−	−			**3** Tone reproduction

MOIRE PATTERNS ▶

Moire Patterns: Interference patterns caused by overprinting two or more lines or halftone screens which periodically reinforce each other, creating a light and dark wavelike pattern.

Detection: In single-color work, check for doubling (Figure A). In multi-color work, check the image register. (See also Image Width; Image Length; Image Twist; Image Low; Image Lateral, and Image Distortion.) In four-color process work a small moire in the form of rosettes is always present and should be ignored (Figure B).

If doubling is absent and the images are in register, the camera screen angles may be at fault. See Figure C.

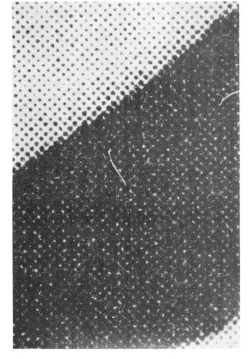

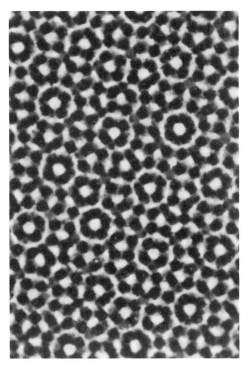

Figure A: Bar pattern moire due to a very faint doubling.

Figure B: Normal rosette moire in four-color printing.

To decrease moire patterns you have these options:

Quick Reference Chart ▶

Figure C: Plaid moire in background due to incorrect screen angles.

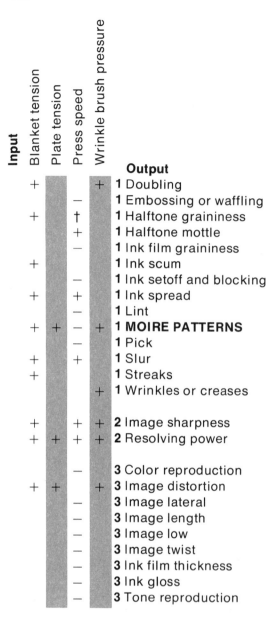

Input	Blanket tension	Plate tension	Press speed	Wrinkle brush pressure	Output
	+			+	**1** Doubling
			−		**1** Embossing or waffling
	+		†		**1** Halftone graininess
			+		**1** Halftone mottle
			−		**1** Ink film graininess
	+				**1** Ink scum
			−		**1** Ink setoff and blocking
	+		+		**1** Ink spread
			−		**1** Lint
	+	+	−	+	**1 MOIRE PATTERNS**
			−		**1** Pick
	+		+		**1** Slur
	+				**1** Streaks
				+	**1** Wrinkles or creases
	+		+	+	**2** Image sharpness
	+	+	+	+	**2** Resolving power
			−		**3** Color reproduction
	+	+		+	**3** Image distortion
			−		**3** Image lateral
			−		**3** Image length
			−		**3** Image low
			−		**3** Image twist
			−		**3** Ink film thickness
			−		**3** Ink gloss
			−		**3** Tone reproduction

PICK ◗

Pick: The delamination, splitting, or tearing of the paper surface by the resistance of the ink film to being split between blanket and paper. Picking can occur in several forms, as follows:

1. Lifting of small clumps of fibers (uncoated paper) or small flakes (coated papers) from the surface of the paper. See Figure A.
2. Lifting of large areas of fibers or coating, often with the paper splitting or tearing to the back edge of the sheet. See Figure B.
3. Blistering or delamination, sometimes with parts of the paper surface sticking to the blanket. See Figure C.

Detection: Picking principally occurs in solids and particularly in those near the back edge of the sheets. In the case of small spots, there is a question whether they are due to pick or slitter dust. To find the cause, select a typical spot and, by thumbing down through the pile, find the sheet where it first appears. Examine the spot with a magnifier to determine if the surface of the paper shows a hole or depression. If it doesn't, the cause of the spot was a loose particle on the sheet. Blistering or delamination can be detected by viewing with a low angle light source or by touching to find if the surface feels rough.

Synonyms: Pick-outs; Delamination; Splits

Reference: GATF's *Paper* book; pp. 42-44

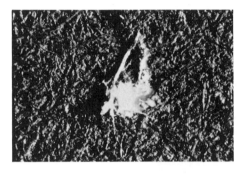

Figure A: Photomicrograph of a pick-out on uncoated paper. Note the disturbed fibers.

Figure B: V-shaped tear at the back edge of a sheet caused by either tacky ink or weak paper.

To decrease pick you have these options:

The following inputs may influence pick, *but the relationship between the inputs and* pick *is not well understood at this time:*

Ink feed
Percent alcohol in fountain
Dampener chiller temperature

Quick Reference Chart ▶

Figure C: Delamination blisters on surface of sheet caused by tacky ink of the lighter background solid.

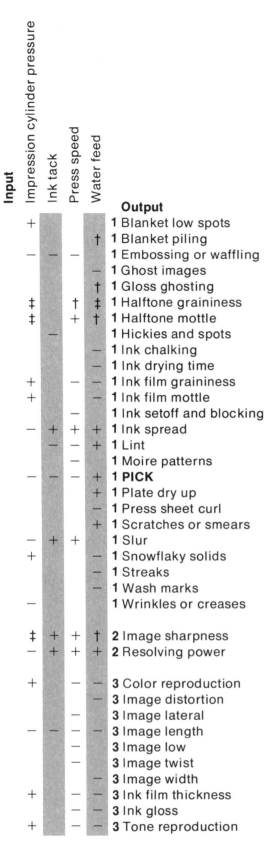

Impression cylinder pressure	Ink tack	Press speed	Water feed	Output
+				**1** Blanket low spots
			†	**1** Blanket piling
−	−	−		**1** Embossing or waffling
			−	**1** Ghost images
			†	**1** Gloss ghosting
‡		†	‡	**1** Halftone graininess
‡		+	†	**1** Halftone mottle
	−			**1** Hickies and spots
			−	**1** Ink chalking
			−	**1** Ink drying time
+	−		−	**1** Ink film graininess
+	−		−	**1** Ink film mottle
			−	**1** Ink setoff and blocking
−	+	+	+	**1** Ink spread
	−	−	+	**1** Lint
			−	**1** Moire patterns
−	−	−	+	**1 PICK**
			+	**1** Plate dry up
			−	**1** Press sheet curl
			+	**1** Scratches or smears
−	+	+		**1** Slur
+			−	**1** Snowflaky solids
			−	**1** Streaks
			−	**1** Wash marks
−				**1** Wrinkles or creases
‡	+	+	†	**2** Image sharpness
−	+	+	+	**2** Resolving power
+		−	−	**3** Color reproduction
			−	**3** Image distortion
			−	**3** Image lateral
−	−	−	−	**3** Image length
			−	**3** Image low
			−	**3** Image twist
			−	**3** Image width
+		−	−	**3** Ink film thickness
			−	**3** Ink gloss
+		−	−	**3** Tone reproduction

Input

PLATE DRY UP ▶

Plate Dry Up: Non-image areas of the plate lose their desensitization due to lack of water, and begin to take ink.

Detection: Examine fine shadow dots as lack of water will cause them to fill in before the more open non-image areas will begin to accept ink. If increasing the water feed does not open the filled-in dots, then see section on Ink Scum.

Synonym: Plate catch up

Reference: GATF's *Press Operating* book; pp. 51-54

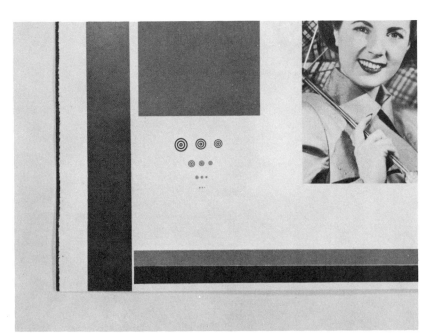

Photograph of a section of a press sheet showing dry up at edge of plate (far left) and plugging-in of dark tones of the gray scale (vertical band at left).

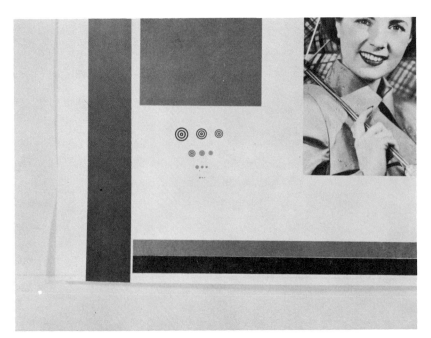

Press sheet from same plate as figure above after increasing the water feed rate. Shadow dots have opened and ink band at left edge has disappeared.

To decrease plate dry up you have these options:

* Decrease the ink feed ... 155
* Increase the percent alcohol in fountain 155
* Increase the water feed ... 157
 Increase press speed (for conventional
 dampening system) ... 156
 Check the dampener roller settings.
 Check the form roller settings.
 Change to new dampener covers.

The following input may influence plate dry up, *but the relationship between the input and* plate dry up *is not well understood at this time.*

Quick Reference Chart ▶

 Dampener chiller temperature

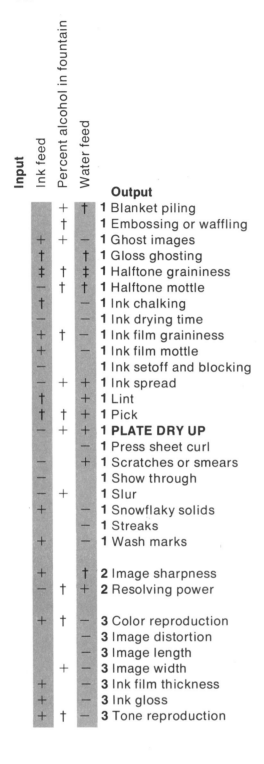

Ink feed	Percent alcohol in fountain	Water feed	Output
	+	†	**1** Blanket piling
	†		**1** Embossing or waffling
+	+	−	**1** Ghost images
†		†	**1** Gloss ghosting
‡	†	‡	**1** Halftone graininess
−	†	†	**1** Halftone mottle
†		−	**1** Ink chalking
			1 Ink drying time
+	†	−	**1** Ink film graininess
+		−	**1** Ink film mottle
−			**1** Ink setoff and blocking
−	+	+	**1** Ink spread
†		+	**1** Lint
†	†	+	**1** Pick
−	+	+	**1 PLATE DRY UP**
		−	**1** Press sheet curl
−		+	**1** Scratches or smears
−			**1** Show through
−	+		**1** Slur
+		−	**1** Snowflaky solids
		−	**1** Streaks
+		−	**1** Wash marks
+		†	**2** Image sharpness
−	†	+	**2** Resolving power
+	†	−	**3** Color reproduction
		−	**3** Image distortion
		−	**3** Image length
	+	−	**3** Image width
+		−	**3** Ink film thickness
+		−	**3** Ink gloss
+	†	−	**3** Tone reproduction

PLATE SHARPENING AND WEAR ▶

Plate Sharpening and Wear: The eroding, blinding, or wearing away of the plate image areas, and scumming of the non-image areas.

Detection: Examine fine highlight dots for loss of dot area or tone value. Also, make comparisons with first sheets from run. If a GATF Sensitivity Guide is on the plate, examine for loss of lightest gray steps. Examine non-image areas for scum.

Reference: GATF's *Press Troubles* book; pp. 56-58

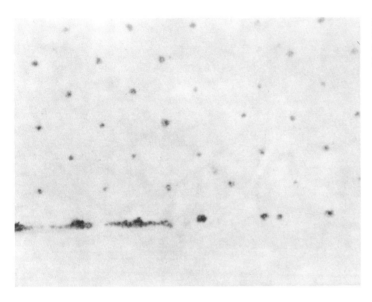

A 64X photomicrograph of very fine (1 percent) highlight dots on press sheet at start of press run.

A 64X photomicrograph of same area as in figure above after 3,000 impressions. Notice several of the dots have worn away.

*To decrease plate sharpening and wear you have these
options:*

* Decrease the blanket packing caliper. 153
* Check the dampener roller settings to the plate.
* Check the form roller settings to the plate.
* Decrease the plate packing caliper. 156
* Decrease the water fountain acidity. 157
 Change to a paper having less abrasiveness 160
 Contact the plate supplier.
 Change to a more compressible blanket. 162
 Change to a more durable plate.

The following inputs may influence plate sharpening and
wear, *but the relationship between the inputs and* plate
sharpening and wear *is not well understood at this time:*

Ink abrasiveness
Water fountain ions
Water fountain gums

Quick Reference Chart ▶

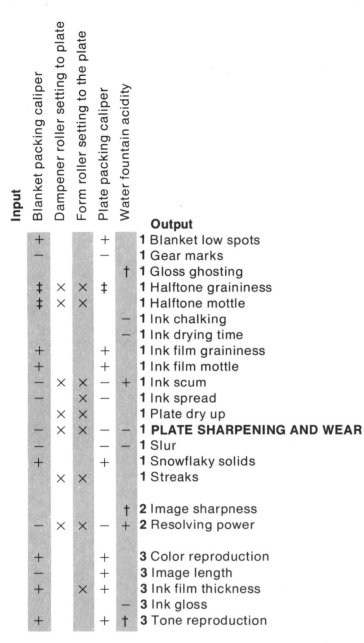

Input

Blanket packing caliper	Dampener roller setting to plate	Form roller setting to the plate	Plate packing caliper	Water fountain acidity	**Output**
+			+		**1** Blanket low spots
−			−		**1** Gear marks
				†	**1** Gloss ghosting
‡	×	×	‡		**1** Halftone graininess
‡	×	×			**1** Halftone mottle
				−	**1** Ink chalking
				−	**1** Ink drying time
+			+		**1** Ink film graininess
+			+		**1** Ink film mottle
−	×	×	−	+	**1** Ink scum
	×	×	−		**1** Ink spread
	×	×			**1** Plate dry up
−	×	×	−	−	**1 PLATE SHARPENING AND WEAR**
			−	−	**1** Slur
+			+		**1** Snowflaky solids
	×	×			**1** Streaks
				†	**2** Image sharpness
−	×	×	−	+	**2** Resolving power
+			+		**3** Color reproduction
−			+		**3** Image length
+		×	+		**3** Ink film thickness
				−	**3** Ink gloss
+			+	†	**3** Tone reproduction

PRESS SHEET CURL ▶

Press Sheet Curl: The degree of reel or moisture curl in the sheet following the impression.

Detection: Hang sheet by gripper edge and observe curvature of sheet. If the sheet curves in a smooth, continuous curve, it is curl (see figures below). If curvature is abrupt and just at the tail edge, it is "tail-end hook" (see Figure B at Embossing-Waffling).

Reference: GATF's *Paper* book; pp. 91-94

Pack of labels showing permanent curl both with and against the paper grain as a result of either too much press moisture or excessively curly paper.

Calendar pad showing permanent curl against the paper grain resulting from the same causes as mentioned in the caption above.

To decrease press sheet curl you have these options:

Input / Water feed

Output

†	**1**	Blanket piling
−	**1**	Ghost images
†	**1**	Gloss ghosting
‡	**1**	Halftone graininess
†	**1**	Halftone mottle
−	**1**	Ink chalking
−	**1**	Ink drying time
−	**1**	Ink film graininess
−	**1**	Ink film mottle
+	**1**	Ink spread
+	**1**	Lint
+	**1**	Pick
+	**1**	Plate dry up
	1	**PRESS SHEET CURL**
+	**1**	Scratches or smears
−	**1**	Snowflaky solids
−	**1**	Streaks
−	**1**	Wash marks
†	**2**	Image sharpness
+	**2**	Resolving power
−	**3**	Color reproduction
−	**3**	Image distortion
−	**3**	Image length
−	**3**	Image width
−	**3**	Ink film thickness
−	**3**	Ink gloss
−	**3**	Tone reproduction

Resolving Power: The finest detail or ruled screen pattern that can be printed on the press sheet. Usually expressed in number of lines per inch.

Detection: Resolving power varies with the orientation of the lines on the press sheet. A GATF Star Target allows the resolving power to be measured at any angle in the sheet. The resolution can also be estimated by measuring the smallest shadow dots on the plate which have remained open on the press sheet.

Synonyms: Fineness of detail; Image resolution

Reference: GATF Research Progress No. 52

An **8X** photomicrograph of a GATF Star Target printed on enamel paper. The resolving power is in excess of 1,600 lines per inch.

An **8X** photomicrograph of a GATF Star Target on enamel paper. Ink spread — dark solid at center — has caused the resolving power to drop to 440 lines per inch.

To increase resolving power you have these options:

The following inputs may influence resolving power, *but
the relationship between the inputs and* resolving power *is
not well understood at this time:*

Percent alcohol in fountain
Ink, oxidative drying
Ink, quicker-setting
Ink, high-gloss
Water fountain ions
Water fountain gums

Quick Reference Chart ◗

Input

Blanket packing caliper	Blanket tension	Dampener roller setting to plate	Form roller setting to the plate	Impression cylinder pressure	Ink feed	Ink tack	Plate packing caliper	Plate tension	Press speed	Water feed	Water fountain acidity	Wrinkle brush pressure	Output
+				+			+						1 Blanket low spots
										+			1 Blanket piling
	−											−	1 Doubling
									‡				1 Embossing-Waffling
−				−			−						1 Gear marks
					+					−			1 Ghost images
					†					†	†		1 Gloss ghosting
‡	+	×	×	‡	‡		‡		†	‡	†		1 Halftone graininess
‡		×	×	‡	−				+	†			1 Halftone mottle
							−						1 Hickies and spots
					†						−		1 Ink chalking
											−		1 Ink drying time
+				+	+		+			−			1 Ink film graininess
+				+	+		+						1 Ink film mottle
−	+	×	×				−				+		1 Ink scum
					−				−				1 Ink setoff and blocking
−	+	×		−	−	+	−		+	+			1 Ink spread
					†	−			−	+			1 Lint
	+							+	−			+	1 Moire patterns
				−	†	−			−	+			1 Pick
		×	×							+			1 Plate dry up
−		×	×				−			−			1 Plate sharpening or wear
										−			1 Press sheet curl
				−						+			1 Scratches or smears
				−									1 Show through
−	+			−	−	+	−		+				1 Slur
+				+	+		+			−			1 Snowflaky solids
	+	×	×							−			1 Streaks
					+					−			1 Wash marks
				−								+	1 Wrinkles or creases
	+			‡	+	+			+	†	†	+	2 Image sharpness
−	+	×	×	−	−	+	−	+	+	+	+	+	**2 RESOLVING POWER**
+				+	+		+		−	−			3 Color reproduction
	+							+	−			+	3 Image distortion
									−				3 Image lateral
−				−		−	+		−	−			3 Image length
									−				3 Image low
									−				3 Image twist
													3 Image width
+			×	+	+		+		−	−			3 Ink film thickness
					+						−		3 Ink gloss
+				+	+		+		−	−		†	3 Tone reproduction

SCRATCHES AND SMEARS ▶

Scratches and Smears: Marks on the press sheet such as light scratches in the ink film and dark ink smears in whites.

Detection: Marks will vary from sheet to sheet in the delivery pile. They sometimes appear as indistinct smudges. Fine scratches are often due to large anti-offset spray powders rolling or sliding between wet sheets as they are jogged in the delivery pile.

Synonyms: Smudging; Ink tracks

Reference: GATF's *Ink* book; pp. 136, 142

Smear or smudging due to lack of rub-resistance in ink film.

Photomicrograph of halftone showing scratches produced by anti-offset spray particles during jogging of the wet press sheets.

To decrease scratches and smears you have these options: FOR CONSEQUENCES
SEE PAGES

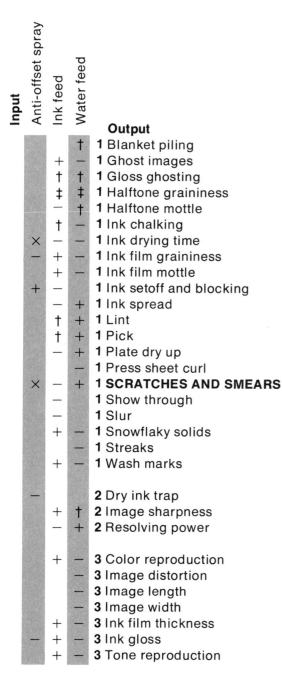

Anti-offset spray	Ink feed	Water feed	Output
		†	**1** Blanket piling
	+	−	**1** Ghost images
	†	†	**1** Gloss ghosting
	‡	‡	**1** Halftone graininess
	−	†	**1** Halftone mottle
	†	−	**1** Ink chalking
×	−	−	**1** Ink drying time
−	+	−	**1** Ink film graininess
	+	−	**1** Ink film mottle
+	−		**1** Ink setoff and blocking
	−	+	**1** Ink spread
	†	+	**1** Lint
	†	+	**1** Pick
	−	+	**1** Plate dry up
		−	**1** Press sheet curl
×	−	+	**1 SCRATCHES AND SMEARS**
	−		**1** Show through
	−		**1** Slur
	+	−	**1** Snowflaky solids
		−	**1** Streaks
	+	−	**1** Wash marks
−			**2** Dry ink trap
	+	†	**2** Image sharpness
	−	+	**2** Resolving power
	+	−	**3** Color reproduction
		−	**3** Image distortion
		−	**3** Image length
		−	**3** Image width
	+	−	**3** Ink film thickness
−	+	−	**3** Ink gloss
	+	−	**3** Tone reproduction

Show Through: Degree of visibility of the printing on the underside of the press sheet, or that of the sheet underneath. This should not be confused with strike through, which results from the ink penetrating into and through the sheet, or with ink setoff (see page 90).

Detection: Lay printed sheet face down on pad of unprinted paper and estimate how well the printing is obscured when viewed through the paper.

Reference: GATF's *Paper* book; pp. 8, 52-53, 121-122

This figure shows the same press sheet face up (upper figure) and face down (below) on a pad of the unprinted paper.

SHOW THROUGH

To decrease show through you have these options: FOR CONSEQUENCES
 SEE PAGES

Input
Ink feed

Output
+ **1** Ghost images
† **1** Gloss ghosting
‡ **1** Halftone graininess
− **1** Halftone mottle
† **1** Ink chalking
− **1** Ink drying time
+ **1** Ink film graininess
+ **1** Ink film mottle
− **1** Ink setoff and blocking
− **1** Ink spread
† **1** Lint
† **1** Pick
− **1** Plate dry up
− **1** Scratches or smears
− **1 SHOW THROUGH**
− **1** Slur
+ **1** Snowflaky solids
+ **1** Wash marks

+ **2** Image sharpness
− **2** Resolving power

+ **3** Color reproduction
+ **3** Ink film thickness
+ **3** Ink gloss
+ **3** Tone reproduction

Slur: Smearing of trailing edges of dots, resulting in a tapering of the ink film into the white areas. Line and text material show the same kind of smear at their trailing edges. Dot slur is usually more easily seen in shadow dots where the greater inked area acts as a lubricant for the slurring force.

Detection: Examine fine shadow dots; slur will appear as a thin veil of ink over the white dots (Figure A). In type, examine the horizontal strokes, as in 'T' and 'E'; slur will appear as a feathered edge toward the trailing edge of the sheet (Figure B). Slur causes an oval to form in the center of a Star Target (Figure C).

References: GATF's *Press Troubles* book; pp. 28, 52, 74, 81, 97
GATF Research Progress No. 52

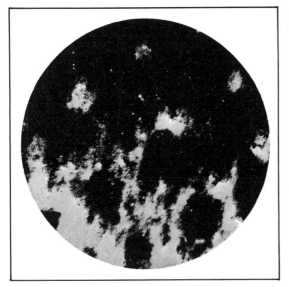

Figure A: Photomicrograph of slur in halftones on enamel paper.

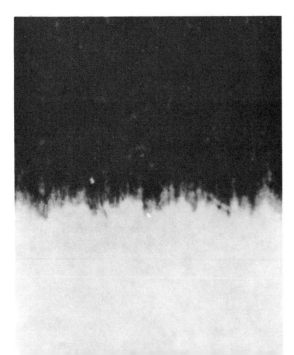

Figure B: Photomicrograph of slur at trailing edge of a line.

To decrease slur you have these options:

Quick Reference Chart ▶

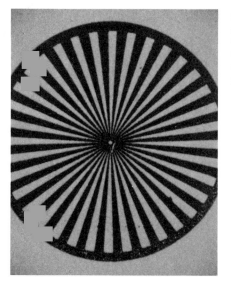

Figure C: Photomicrograph of a GATF Star Target on enamel paper. Press slur in the vertical direction has caused the center of the target to spread to an oval shape.

Input	Blanket packing caliper	Blanket tension	Impression cylinder pressure	Ink feed	Ink tack	Percent alcohol in fountain	Plate packing caliper	Press speed	Blanket compressibility	Output
	+		+				+			1 Blanket low spots
						+				1 Blanket piling
		+								1 Doubling
			−			†		−		1 Embossing or waffling
	−						−		+	1 Gear marks
			+			+				1 Ghost images
				†						1 Gloss ghosting
	‡	+	‡	‡		†	‡	†	+	1 Halftone graininess
	‡	+	‡	−		†	+		†	1 Halftone mottle
				−						1 Hickies and spots
				†						1 Ink chalking
										1 Ink drying time
	+		+	+		†	+	−	−	1 Ink film graininess
	+		+	+			+		+	1 Ink film mottle
	−	+					−			1 Ink scum
				−			−			1 Ink setoff and blocking
	−	+	−	−	+	+	−	+		1 Ink spread
				†	−			−	†	1 Lint
		+						−		1 Moire patterns
			−	†	−	†		−		1 Pick
				−		+				1 Plate dry up
							−		−	1 Plate sharpening or wear
				−						1 Scratches or smears
				−						1 Show through
	−	+	−	−	+	+	−	+	+	**1 SLUR**
	+		+	+			+		−	1 Snowflaky solids
		+							†	1 Streaks
			+							1 Wash marks
			−							1 Wrinkles or creases
		+	‡	+	+			+	+	2 Image sharpness
	−	+	−	−	+	†	−	+	+	2 Resolving power
	+		+	+		†	+	−	−	3 Color reproduction
		+								3 Image distortion
							−			3 Image lateral
	−		−	−		+	−		†	3 Image length
							−			3 Image low
							−			3 Image twist
						+				3 Image width
	+		+	+			+			3 Ink film thickness
				+						3 Ink gloss
	+		+	+		†	+		−	3 Tone reproduction

SNOWFLAKY SOLIDS ▶

Snowflaky Solids: Minute white spots or holes in the ink film solids on the press sheet.

Detection: Examine the sheet at normal viewing distance and if snowflakiness seems greater toward the center it generally indicates lack of impression between plate and blanket or blanket and impression cylinder. If the snowflakiness seems worse in wide bands from the gripper to trailing edge, it generally indicates excessive water or too thin an ink film. (See also Wash Marks.)

Reference: GATF's *Paper* book; pp. 107-108

A 12X photomicrograph of a snowflaky solid.

A 64X photomicrograph of a snowflaky solid. The light spots are due to areas of the paper surface which are not covered by the ink film.

To decrease snowflaky solids you have these options: FOR CONSEQUENCES
 SEE PAGES

Quick Reference Chart ▶

| Input | | | | | Output |
Blanket packing caliper	Impression cylinder pressure	Ink feed	Plate packing caliper	Water feed	
+	+			+	1 Blanket low spots
				†	1 Blanket piling
	−				1 Embossing or waffling
−			−		1 Gear marks
		+		−	1 Ghost images
		†		†	1 Gloss ghosting
‡	‡	‡	‡	‡	1 Halftone graininess
‡	‡	−		†	1 Halftone mottle
		†			1 Ink chalking
		−		−	1 Ink drying time
+	+	+	+	−	1 Ink film graininess
+	+	+	+	−	1 Ink film mottle
−			−		1 Ink scum
		−			1 Ink setoff and blocking
−	−	−	−	+	1 Ink spread
		†		+	1 Lint
	−	†		+	1 Pick
		−		+	1 Plate dry up
−			−		1 Plate sharpening or wear
				−	1 Press sheet curl
		−		+	1 Scratches or smears
		−			1 Show through
−	−	−	−		1 Slur
+	+	+	+	−	**1 SNOWFLAKY SOLIDS**
				−	1 Streaks
		+		−	1 Wash marks
−					1 Wrinkles or creases
	‡	+		†	2 Image sharpness
−	−	−	−	+	2 Resolving power
+	+	+	+	−	3 Color reproduction
				−	3 Image distortion
−	−		+	−	3 Image length
				−	3 Image width
+	+	+	+	−	3 Ink film thickness
		+		−	3 Ink gloss
+	+	+	+	−	3 Tone reproduction

STREAKS ▶

Streaks: Light or dark stripes in the image which are either parallel or vertical to the gripper edge, and bear no relationship to the pitch of the gear teeth.

Detection: View press sheet at normal viewing distance and examine dark tone areas and solids for presence of streaks.

Reference: GATF's *Press Troubles* book; pp. 26, 34, 64

A press sheet showing numerous fine vertical (around-the-cylinder direction) streaks due to abrasion of the plate.

A press sheet showing numerous vertical (around the cylinder direction) randomly spaced streaks of varying widths due to poorly adjusted dampeners or dampener covers in poor condition. Note the light horizontal bands at the bottom of the illustration; these are usually caused by excessive dampener form roller end play.

The wash marks on the edges of the logo indicate excessive water feed. (See Wash Marks, page 142.)

To decrease streaks you have these options:

* Increase the blanket tension. 153
* Check the dampener roller settings to the plate.
* Check the form roller settings to the plate.
* Decrease the water feed . 157
 Decrease the dampener end play. 162

The following input may influence streaks *but the relationship between the input and* streaks *is not well understood at this time:*

Blanket compressibility

Quick Reference Chart ▶

Blanket tension	Dampener roller setting to plate	Form roller setting to the plate	Water feed	Output
			†	**1** Blanket piling
+				**1** Doubling
			−	**1** Ghost images
			†	**1** Gloss ghosting
+	×	×	‡	**1** Halftone graininess
	×	×	†	**1** Halftone mottle
			−	**1** Ink chalking
			−	**1** Ink drying time
			−	**1** Ink film graininess
			−	**1** Ink film mottle
+	×	×		**1** Ink scum
+	×		+	**1** Ink spread
			+	**1** Lint
+				**1** Moire patterns
			+	**1** Pick
	×	×	+	**1** Plate dry up
	×	×		**1** Plate sharpening or wear
			−	**1** Press sheet curl
			+	**1** Scratches or smears
+				**1** Slur
			−	**1** Snowflaky solids
+	×	×	−	**1 STREAKS**
			−	**1** Wash marks
+			†	**2** Image sharpness
+	×	×	+	**2** Resolving power
			−	**3** Color reproduction
+			−	**3** Image distortion
			−	**3** Image length
			−	**3** Image width
		×	−	**3** Ink film thickness
			−	**3** Ink gloss
			−	**3** Tone reproduction

TONE REPRODUCTION ▶

Tone Reproduction: Relationship between the lightness, or tone values, of corresponding areas in the original copy and the press sheet. This relationship can be described by a curve showing the reflection densities of the original copy plotted against the corresponding densities on an inspection press sheet (Figure B).

Detection: Visually compare, or measure with a densitometer, corresponding tone areas in the original copy and press sheet; e.g., a 70 per cent dot in a halftone. Figure C shows how this value and the entire curve change using a change in ink film thickness as an example. Figure A shows the press sheets plotted in Figure C.

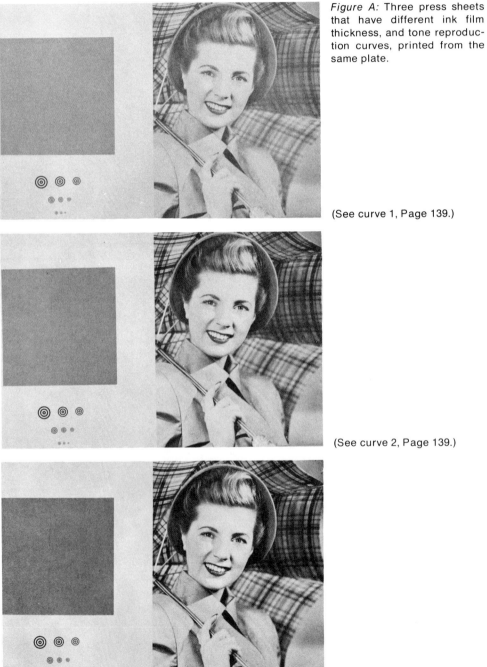

Figure A: Three press sheets that have different ink film thickness, and tone reproduction curves, printed from the same plate.

(See curve 1, Page 139.)

(See curve 2, Page 139.)

(See curve 3, Page 139.)

*To increase the tone value of the 70 percent tint you
have these options:*

The following inputs may influence tone reproduction, *but
the relationship between the inputs and* tone reproduction *is
not well understood at this time:*

Percent alcohol in fountain
Water fountain acidity
Ink, oxidative drying
Water fountain ions
Water fountain gums

Quick Reference Chart ◗

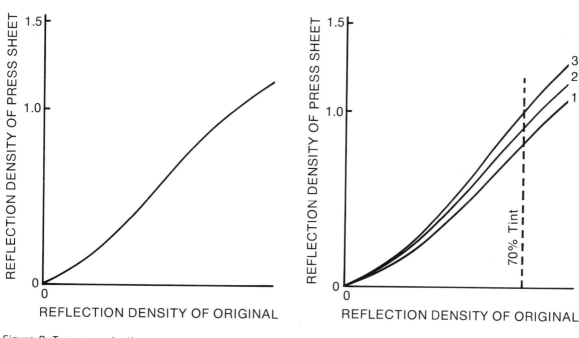

Figure B: Tone reproduction curve showing relation-
ship between reflection densities on original and press
sheet.

Figure C: Tone reproduction curves of three press
sheets in Figure A.

Input						Output
Blanket packing caliper	Impression cylinder pressure	Ink feed	Plate packing caliper	Press speed	Water feed	
+	+		+			1 Blanket low spots
					†	1 Blanket piling
	−			−		1 Embossing or waffling
−			−			1 Gear marks
		+			−	1 Ghost images
	†				†	1 Gloss ghosting
‡	‡	‡	‡	†	‡	1 Halftone graininess
‡	‡	−	+		†	1 Halftone mottle
	†				−	1 Ink chalking
	−				−	1 Ink drying time
+	+	+	+	−	−	1 Ink film graininess
+	+	+	+		−	1 Ink film mottle
−			−			1 Ink scum
			−		−	1 Ink setoff and blocking
−	−	−	−	+	+	1 Ink spread
		†		−	+	1 Lint
				−		1 Moire patterns
	−	†		−	+	1 Pick
		−			+	1 Plate dry up
−			−			1 Plate sharpening or wear
					−	1 Press sheet curl
				−	+	1 Scratches or smears
				−		1 Show through
−	−	−	−	+		1 Slur
+	+	+	+		−	1 Snowflaky solids
					−	1 Streaks
		+			−	1 Wash marks
	−					1 Wrinkles or creases
	‡	+		+	†	2 Image sharpness
−	−	−	−	+	+	2 Resolving power
+	+	+	+	−	−	3 Color reproduction
					−	3 Image distortion
				−		3 Image lateral
−	−		+	−	−	3 Image length
				−		3 Image low
				−		3 Image twist
					−	3 Image width
+	+	+	+	−	−	3 Ink film thickness
		+		−	−	3 Ink gloss
+	+	+	+	−	−	3 **TONE REPRODUCTION**

WASH MARKS ♦

Wash Marks: Ragged areas of low ink density which extend back from the leading edges of the image.

Detection: Examine the leading edges of dark tones and solids. Wash marks will appear as very snowflaky areas extending toward the back or trailing edge of the sheet.

Reference: GATF's *Press Troubles* book; pp. 41-42

A 12X photomicrograph of a wash mark at the leading edge (top of figure) of a solid on a press sheet.

To decrease wash marks you have these options:

FOR CONSEQUENCES
SEE PAGES

* Increase the ink feed . 155
* Decrease the water feed . 157

Input		Output
Ink feed	**Water feed**	
	†	**1** Blanket piling
+	−	**1** Ghost images
†	†	**1** Gloss ghosting
‡	‡	**1** Halftone graininess
−	†	**1** Halftone mottle
†	−	**1** Ink chalking
−	−	**1** Ink drying time
+	−	**1** Ink film graininess
+	−	**1** Ink film mottle
−		**1** Ink setoff and blocking
−	+	**1** Ink spread
†	+	**1** Lint
†	+	**1** Pick
−	+	**1** Plate dry up
	−	**1** Press sheet curl
−	+	**1** Scratches or smears
−		**1** Show through
−		**1** Slur
+	−	**1** Snowflaky solids
	−	**1** Streaks
+	−	**1 WASH MARKS**
+	†	**2** Image sharpness
−	+	**2** Resolving power
+	−	**3** Color reproduction
	−	**3** Image distortion
	−	**3** Image length
	−	**3** Image width
+	−	**3** Ink film thickness
+	−	**3** Ink gloss
+	−	**3** Tone reproduction

Wrinkles and Creases: Folds pressed into the sheet during impression, due to either improper mechanical press adjustments or to some undesirable condition in the paper.

Detection: Wrinkles and creases usually occur toward the middle and trailing edge of sheet. Wrinkling may not occur continuously so several successive sheets in the delivery pile should be checked.

Reference: GATF's *Paper* book; pp. 33-34, 87

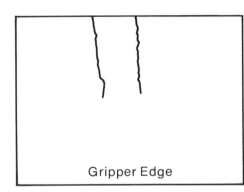

Position of wrinkles caused by wavy-edged paper.

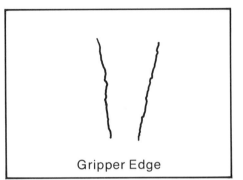

Position of wrinkles caused by tight-edged paper.

To decrease wrinkles and creases you have these options:

FOR CONSEQUENCES
SEE PAGES

* Increase the front edge setting (concave, if paper
 is wavy edged) . 154
* Decrease the front edge setting (convex, if paper is
 tight edged). 154
* Decrease the impression cylinder pressure 154
* Increase the wrinkle brush pressure . 158
* Change to a paper having greater flatness. 159
 Contact the press manufacturer.

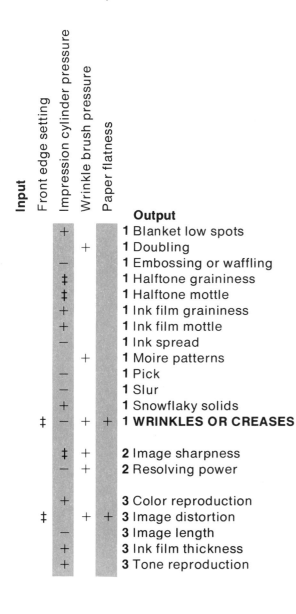

Input				Output
Front edge setting	Impression cylinder pressure	Wrinkle brush pressure	Paper flatness	
	+			**1** Blanket low spots
		+		**1** Doubling
	−			**1** Embossing or waffling
	‡			**1** Halftone graininess
	‡			**1** Halftone mottle
	+			**1** Ink film graininess
	+			**1** Ink film mottle
	−			**1** Ink spread
		+		**1** Moire patterns
	−			**1** Pick
	−			**1** Slur
	+			**1** Snowflaky solids
‡	−	+	+	**1 WRINKLES OR CREASES**
	‡	+		**2** Image sharpness
	−	+		**2** Resolving power
	+			**3** Color reproduction
‡		+	+	**3** Image distortion
	−			**3** Image length
	+			**3** Ink film thickness
	+			**3** Tone reproduction

The Master Chart

The Master Chart is a condensation of all the information in this handbook. Whereas the individual Quick Reference Charts contain *only* the starred inputs for a given output, the Master Chart plots the interactions between *all* the inputs and outputs. The chart is a convenient means to study these complex interactions on a single sheet.

The Master Chart

How to Use the Master Chart

The column at the left of the chart lists the outputs or print quality variables of the press sheet. They are divided into three groups:

Group **1** (upper) are the outputs we normally desire to decrease or eliminate.

Group **2** (middle) are the outputs we normally desire to increase.

Group **3** (lower) are the outputs we may desire to either increase or decrease in order to: improve register; match copy, proof book, or OK sheet.

The column headings (bottom of the chart) form a list of inputs (see pages 9-11). The inputs are arranged so that the simplest to change are toward the left while the more difficult, such as re-ordering paper or ink, are toward the right. In solving a problem, it is usually preferable to manipulate or adjust those inputs at the left, and use those toward the right only if all else fails.

To use the chart, first locate the output you wish to adjust. We will call this the *Main Output.* In the row of the Main Output are symbols at the intersections with columns of inputs. For example, if **Wash Marks** is the Main Output, we find symbols (same as those in the Quick Reference Charts) at **Water Feed** and **Ink Feed.**

The meaning of these symbols are:

+ The input should be *increased.*

− The input should be *decreased*.

‡ The input may have to be either increased or decreased to achieve the desired effect. Experience and logic will help in deciding the direction in which to adjust the input.

× The input should be checked to see if it is functioning properly. It means, also, to check with the appropriate supplier.

† The input is thought to influence the output, but the interaction is not well understood.

If the Main Output is in group **1**, the symbols indicate the direction the inputs should be changed to *minimize* that output. (Notice the column headed "To Change in This Direction"; all the symbols opposite group **1** are "−", which means "to decrease.")

If the Main Output is in group **2**, the symbols indicate the direction the inputs should be changed to *increase* that output. (Notice the column headed "To Change in This Direction"; all the symbols opposite group **2** are "+", which means "to increase.")

Group **3** of the Main Outputs had to be handled a bit differently. Here, the column headed "To Change in This Direction" shows both *increase* (+) and

decrease (−) symbols. This simply means that, if we change the input in the direction indicated in the appropriate column, the output will change in the direction indicated in the column headed "To Change in This Direction."

When there are two or more inputs indicated in a Main Output row, the following strategy may help in selecting which of the inputs to change.

If the other symbols in the column of an input are the same as that of the Main Output, adjusting this input will probably have no harmful effects on other print quality variables of the press sheet. If some of the symbols are of the opposite sign, there may be a tendency for those print quality variables to become worse. It is advisable to pick the input that is easiest to adjust, and which has most of its symbols in the same sign as the Main Output.

For illustrative purposes see page 5, which describes how to handle a variety of complex situations.

The Consequences — Effects of the Inputs

With the discussion of each output there are listed the remedial actions which may reduce (remedy) that particular print quality fault. However, as everyone recognizes, any step that might be taken to alleviate a specific problem may result in other undesirable print quality changes.

Opposite each asterisked input (remedial action) there is the page number in this *consequences* section on which the results of that action are listed. All the remedies listed are referenced to all known consequences of each suggested remedial action.

The Consequences

Increasing the Anti-offset Spray is likely to result in:

> Decreased Dry Ink Trap
> Increased Ink Film Graininess
> Decreased Ink Gloss
> Decreased Ink Setoff and Blocking

Increasing the Blanket Packing Caliper is likely to result in:

> Decreased Blanket Low Spots
> Increased Color Reproduction
> Increased Gear Marks
> Increased Image Length
> Decreased Ink Film Graininess
> Decreased Ink Film Mottle
> Increased Ink Film Thickness
> Increased Ink Scum
> Increased Ink Spread
> Increased Plate Sharpening or Wear
> Decreased Resolving Power
> Increased Slur
> Decreased Snowflaky Solids
> Increased Tone Reproduction

The Following Can Go Either Way Depending on Existing Conditions:

> Halftone Graininess
> Halftone Mottle

Increasing the Blanket Tension is likely to result in:

> Decreased Doubling
> Decreased Halftone Graininess
> Decreased Image Distortion
> Increased Image Sharpness
> Decreased Ink Scum
> Decreased Ink Spread
> Increased Resolving Power
> Decreased Slur
> Decreased Streaks

Increasing the Delivery Pile Height is likely
to result in:

> Increased Ink Drying Time
> Increased Ink Setoff and Blocking

Changing the Front Edge Setting may result in
outputs changing depending on existing conditions:

> Image Distortion
> Wrinkles and Creases

Increasing the Impression Cylinder Pressure
is likely to result in:

> Decreased Blanket Low Spots
> Increased Color Reproduction
> Increased Embossing or Waffling
> Increased Image Length
> Decreased Ink Film Graininess
> Decreased Ink Film Mottle
> Increased Ink Film Thickness
> Increased Ink Spread
> Increased Pick
> Decreased Resolving Power
> Increased Slur
> Decreased Snowflaky Solids
> Increased Tone Reproduction
> Increased Wrinkles or Creases

*The Following Can Go Either Way Depending
on Existing Conditions:*

> Halftone Graininess
> Halftone Mottle
> Image Sharpness

Increasing the Ink Driers is likely to result
in:

> Decreased Ink Chalking
> Decreased Ink Drying Time
> Decreased Ink Film Mottle
> Increased Ink Gloss

Increasing the Ink Feed is likely to result in:

 Increased Color Reproduction
 Decreased Ghost Images
 Increased Halftone Mottle
 Increased Image Sharpness
 Increased Ink Drying Time
 Decreased Ink Film Graininess
 Decreased Ink Film Mottle
 Increased Ink Film Thickness
 Increased Ink Gloss
 Increased Ink Setoff and Blocking
 Increased Ink Spread
 Increased Plate Dry Up
 Decreased Resolving Power
 Increased Scratches or Smears
 Increased Show Through
 Increased Slur
 Decreased Snowflaky Solids
 Increased Tone Reproduction
 Decreased Wash Marks

The Following Can Go Either Way Depending on Existing Conditions:

 Halftone Graininess

Increasing the Ink Tack is likely to result in:

 Increased Embossing — Waffling
 Increased Hickies and Spots
 Increased Image Length
 Increased Image Sharpness
 Decreased Ink Spread
 Increased Lint
 Increased Pick
 Increased Resolving Power
 Decreased Slur

Increasing the Percent Alcohol in Fountain is likely to result in:

 Decreased Blanket Piling
 Decreased Ghost Images
 Decreased Image Width
 Decreased Ink Spread
 Decreased Plate Dry Up
 Decreased Slur

Increasing the Plate Packing Caliper is
likely to result in:

> Decreased Blanket Low Spots
> Increased Color Reproduction
> Increased Gear Marks
> Decreased Image Length
> Decreased Ink Film Graininess
> Decreased Ink Film Mottle
> Increased Ink Film Thickness
> Increased Ink Scum
> Increased Ink Spread
> Increased Plate Sharpening or Wear
> Decreased Resolving Power
> Increased Slur
> Decreased Snowflaky Solids
> Increased Tone Reproduction

*The Following Can Go Either Way Depending
on Existing Conditions:*

> Halftone Graininess

Increasing the Plate Tension is likely to
result in:

> Decreased Image Distortion
> Increased Resolving Power

Increasing the Press Speed is likely to result
in:

> Decreased Color Reproduction
> Increased Embossing — Waffling
> Decreased Halftone Mottle
> Increased Image Lateral
> Increased Image Length
> Increased Image Low
> Increased Image Sharpness
> Increased Image Twist
> Decreased Ink Film Thickness
> Decreased Ink Gloss
> Increased Ink Setoff and Blocking
> Decreased Ink Spread
> Increased Lint
> Increased Pick
> ~~Decreased~~ Resolving Power
> Decreased Slur
> Decreased Tone Reproduction

Increasing the Time between Overprints is
likely to result in:

> Decreased Dry Ink Trap
> Increased Gloss Ghosting

Increasing the Water Feed is likely to result in:

> Decreased Color Reproduction
> Increased Ghost Images
> Increased Image Distortion
> Increased Image Length
> Increased Image Width
> Increased Ink Chalking
> Increased Ink Drying Time
> Increased Ink Film Graininess
> Increased Ink Film Mottle
> Decreased Ink Film Thickness
> Decreased Ink Gloss
> Decreased Ink Spread
> Decreased Lint
> Decreased Pick
> Decreased Plate Dry Up
> Increased Press Sheet Curl
> Increased Resolving Power
> Decreased Scratches or Smears
> Increased Snowflaky Solids
> Increased Streaks
> Decreased Tone Reproduction
> Increased Wash Marks

*The Following Can Go Either Way Depending
on Existing Conditions:*

> Halftone Graininess

Increasing the Water Fountain Acidity is
likely to result in:

> Increased Ink Chalking
> Increased Ink Drying Time
> Decreased Ink Gloss
> Decreased Ink Scum
> Increased Plate Sharpening or Wear
> Increased Resolving Power

Winding the Sheets is likely to result in:

> Decreased Gloss Ghosting
> Decreased Ink Drying Time

Increasing the Wrinkle Brush Pressure is
likely to result in:

>Decreased Doubling
>Decreased Image Distortion
>Increased Image Sharpness
>Increased Resolving Power
>Decreased Wrinkles or Creases

Paper with Greater Pick Resistance is
likely to result in:

>Decreased Blanket Piling
>Decreased Pick

Paper with Excessive Loosely Bonded Fibers
is likely to result in:

>Increased Lint

Paper of Higher Absorbency is likely to
result in:

>Decreased Color Reproduction
>Decreased Ink Film Graininess
>Decreased Ink Gloss
>Decreased Ink Setoff and Blocking
>Decreased Ink Spread
>Decreased Scratches or Smears
>Increased Show Through
>Decreased Slur
>Decreased Tone Reproduction

Paper of Higher Opacity is likely to
result in:

>Decreased Show Through

Paper with Excessive Surface Dust (Debris)
is likely to result in:

>Increased Blanket Piling
>Increased Hickies and Spots
>Increased Ink Film Graininess
>Increased Ink Spread

Higher Paper Acidity is likely to result in:

> Increased Ink Chalking
> Increased Ink Drying Time
> Decreased Ink Gloss

The Higher the Paper's Smoothness the greater
the likelihood of:

> Increased Color Reproduction
> Decreased Halftone Graininess
> Decreased Ink Film Graininess
> Increased Ink Gloss
> Increased Resolving Power
> Increased Tone Reproduction

Paper with Better Dimensional Stability
is likely to result in:

> Decreased Image Length
> Decreased Image Width

Paper with Higher Moisture Resistance
is likely to result in:

> Decreased Blanket Piling
> Decreased Halftone Graininess
> Decreased Halftone Mottle
> Decreased Ink Film Graininess
> Decreased Ink Spread
> Decreased Slur
> Decreased Snowflaky Solids

Paper with Higher Moisture Content is
likely to result in:

> Decreased Image Length
> Decreased Image Width

The Flatter the Paper, the greater the likelihood
of:

> Decreased Image Distortion
> Decreased Wrinkles or Creases

Paper Having Greater Abrasiveness is likely
to result in:

> Increased Halftone Graininess
> Increased Ink Scum
> Increased Plate Sharpening or Wear

**The Greater the Curling Tendency of the
Paper,** the more likelihood of:

> Increased Image Length
> Increased Press Sheet Curl

**The Better the Straightness-Squareness of
the Paper,** the greater the likelihood of:

> Decreased Image Distortion

Paper with a Higher Temperature is likely
to result in:

> Decreased Image Length
> Decreased Image Width

*The Following Can Go Either Way Depending
on Existing Conditions:*

> Image Distortion

Paper with a Higher Basis Weight or Caliper
is likely to result in:

> Decreased Embossing—Waffling
> Decreased Image Distortion
> Decreased Press Sheet Curl

The Higher the Paper's Index of Refraction,
the greater the likelihood of:

> Decreased Color Reproduction
> Increased Halftone Graininess
> Increased Image Sharpness
> Decreased Tone Reproduction

Paper with a Heavier Coating is likely to
yield:

>Decreased Halftone Graininess
>Decreased Ink Film Graininess
>Increased Ink Gloss
>Increased Resolving Power

The Higher the Paper Gloss the greater the
likelihood of:

>Increased Color Reproduction
>Decreased Ink Film Mottle
>Increased Ink Gloss

Paper with a Higher Limit of Elasticity is
likely to result in:

>Decreased Embossing—Waffling
>Decreased Image Length

Paper with a Higher Degree of Wildness in its formation
is likely to result in:

>Increased Halftone Mottle
>Increased Ink Film Mottle

Paper with a Greater Resistance to Abrasiveness
is likely to result in:

>Decreased Blanket Piling
>Decreased Halftone Graininess
>Decreased Ink Film Graininess
>Decreased Ink Spread
>Decreased Slur

The Higher the Water Receptivity of the Paper,
the greater the likelihood of:

>Decreased Snowflaky Solids

Increasing the Ink Color Strength is likely
to result in:

>Decreased Ink Spread
>Increased Resolving Power

Increasing the Water Fountain Gum is likely
to result in:

Decreased Ink Scum

The Greater the Blanket Compressibility the
more likely the result will be:

Decreased Color Reproduction
Decreased Gear Marks
Decreased Halftone Graininess
Increased Image Sharpness
Increased Ink Film Graininess
Decreased Ink Film Mottle
Decreased Plate Sharpening or Wear
Increased Resolving Power
Decreased Slur
Increased Snowflaky Solids
Decreased Tone Reproduction

Increasing the Dampener Chiller Temperature
is likely to result in:

Increased Ink Spread
Decreased Pick
Increased Resolving Power
Increased Tone Reproduction

Decreasing the Dampener End Play is likely to
result in:

Decreased Streaks

Index

Page numbers in **bold figures** locate the primary reference where the item is defined.

Page numbers in **bold figures** locate the primary reference where the item is defined.

Page numbers in **bold figures** locate the primary reference where the item is defined.

Page numbers in **bold figures** locate the primary reference where the item is defined.

Page numbers in **bold figures** locate the primary reference where the item is defined.

Page numbers in **bold figures** locate the primary reference where the item is defined.